ENGLISH SILVER SPOONS

ENGLISH SILVER SPOONS

MICHAEL SNODIN

Charles Letts and Company Limited

Published by
Charles Letts and Company Limited
Head Office:
Diary House, Borough Road, London SE1 1DW
Photographs: Michael Dyer Associates

The author would particularly like to thank Mrs. Elaine Barr,
Mr. John Culme, and Mr. Ian Pickford for much help generously
given; and Mr. Claude Blair and Mrs. Shirley Bury, who kindly
undertook to read the manuscript and made many valuable suggestions.
He would also like to thank the private collectors and the following
owners who generously allowed pieces from their collections to be
photographed and reproduced:

The Bell Pearson Collection
Bristol City Art Gallery
Christie, Manson & Wood
Ipswich Museum
Thomas Lumley Ltd.
The Marquess of Ormonde
S. J. Shrubsole Ltd.
Sotheby & Co.
Sotheby's Belgravia
Spink and Son
C. J. Vander (Antiques) Ltd.

Unless otherwise stated the spoons in this book are in the collections
of the Victoria and Albert Museum and are reproduced by courtesy
of the Museum

First published 1974
Standard Book Number: 85097 110 1

CONTENTS

INTRODUCTION 7

Plate 1	Wrythen Knop; mid-fifteenth century	17
Plate 2	Acorn Knop; c. 1500	18
Plate 3	Apostle spoon, St. John; 1498	19
Plate 4	Apostle spoon, the Master; 1527	20
Plate 5	Lion sejant; 1530	21
Plate 6	Maidenhead; c. 1580	22
Plate 7	Apostle spoon, the Master; 1607	23
Plate 8	Two Master spoons of 1527 and 1607	23
Plate 9	Terminal figure spoon; c. 1600	24
Plate 10	Slip-top spoons; 1630 and 1631	25
Plate 11	Seal-top spoons; c. 1630 and 1655	26
Plate 12	Apostle spoon, St. Peter; c. 1650	27
Plate 13	Puritan spoon; 1661	28
Plate 14	Notched-end puritan; c. 1670	28
Plate 15	Trifid spoon; c. 1680	29
Plate 16	Six trifid spoons; c. 1674	30
Plate 17	'Lace-back' trifid spoon; c. 1700	31
Plate 18	Condiment spoon and two teaspoons; c. 1680 and 1685	32
Plate 19	Trifid spoons and marrow spoons; 1692-1695	33
Plate 20	Stump-top basting spoon; 1688	34
Plate 21	Basting spoon; 1699	35
Plate 22	Wavy-ended tablespoons; 1707	36
Plate 23	Scottish marrow scoop; c. 1730	37
Plate 24	Hanoverian serving spoon; 1720	38
Plate 25	Hanoverian tablespoons; 1735-1773	39
Plate 26	Hanoverian tablespoons; 1735 and 1746	40
Plate 27	Backs of bowls; 1735 to 1855	40
Plate 28	Picture-backs and fancy-backs; c. 1760-1770	42
Plate 29	Naturalistic rococo teaspoons; c. 1750-1760	43
Plate 30	Decorated stem teaspoons; c. 1739-1750	44
Plate 31	Decorated stem teaspoons and a mote spoon; c. 1750-1765	45
Plate 32	Eagle's head ladle; c. 1740	46
Plate 33	Old English soup ladle; 1764	47
Plate 34	Old English dessert and teaspoons; 1767 and c. 1770	48
Plate 35	Old English tablespoons; 1776	49
Plate 36	Miniature spoons; c. 1695-1799	50
Plate 37	Small ladles; c. 1770-1827	51
Plate 38	Salt spoons, shovels, and ladles; c. 1740-1827	52
Plate 39	Punch and toddy ladles; 1731 to c. 1800	53
Plate 40	Scottish and Irish spoons; 1789 to c. 1800	54

Plate 41 Fiddle Pattern serving spoon; 1798 55
Plate 42 Old English tablespoons; 1802–1823 56
Plate 43 Hourglass Pattern service; 1807 and 1808 57
Plate 44 Sauce ladle and sugar sifter, Stag Hunt and Bacchanalian
 Patterns; 1816 and *c.* 1855 58
Plate 45 Soup ladle, Coburg Pattern; 1819 59
Plate 46 Historicist serving spoons; 1825 60
Plate 47 Dessert spoon; 1839 61
Plate 48 Egg spoons, Albert Pattern; 1848 62
Plate 49 Naturalistic salt spoon and teaspoons; 1835 and 1859 63
Plate 50 Ice spade and dessert serving spoon, Vine Pattern; *c.* 1850 64
Plate 51 Naturalistic ladle; 1853 65
Plate 52 Four teaspoons; *c.* 1850–1872 66
Plate 53 Historicist dessert spoons; 1865 and 1871 67
Plate 54 Figure finial dessert spoon; 1882 68
Plate 55 Electro-plated soup ladle; after 1880 69
Plate 56 Arts and Crafts spoons; 1901 70
Plate 57 Three cast fake slip-tops 71
Plate 58 Continental, converted, and cast spoons 72
Plate 59 Fake apostle finials 73
Plate 60 Later decoration 74

 SELECT BIBLIOGRAPHY 75

 APPENDIX 79

INTRODUCTION

London hall-marks

The earliest known English hall-mark is the *leopard's head,* the heraldic term for a lion's head full face, which was introduced by royal statute in 1300 and called, in a statute of 1363, 'the King's mark'. Its purpose, as in the case of most later hall-marks, was to serve as a guarantee that the silver used had been assayed and shown to be of sterling standard, that is 925 parts or more of silver in 1000 of alloyed metal, all silver having to be slightly alloyed for strength. Various leopard's heads marks in beaded circles, believed to refer to London manufacture, have been found in the bowls of spoons dateable, on form, from about 1300 onwards. The earliest statute requiring maker's marks is dated 1363 but very few appear at such an early date, most spoons of the period being entirely unmarked.

In 1478 the London date-letter system as we now know it was introduced, the letter being struck adjacent to the maker's mark at the back of the stem near the bowl, perhaps causing it to widen. At the same time the *crowned leopard's head* mark was introduced and struck in the bowl, all these marks, and the assay, being then, as now, under the control of the Goldsmiths' Company. Each date letter, one of a cycle of twenty usually omitting J, V, W, X, Y and Z, is introduced in May and therefore also covers the first few months of the following year, but is usually expressed as the earlier year; thus the mark for 1744-5 is called 1744 in this book. Letters have also been found incorporated in some leopard's head marks and are believed to belong to a date-letter or warden's mark system in use shortly before 1478. In 1544 the *lion passant* mark, a lion walking to the left, was added to the other two marks on the back of the stem, probably to denote that the silver used was not of the low standard of contemporary coinage. With the exception of slip-tops, puritans and stump-tops, in which the date letter was struck at the end of the stem, the 1544 placing continued until the introduction of the trifid when the leopard's head crowned was moved to the back of the stem, perhaps because of the difficulty of striking over the rat-tail, the marks being respaced more or less evenly up the stem, beginning at the bowl with the maker's mark and ending with the date-letter (but see Plate 15). In 1697 the 'new sterling' or *Britannia standard* of 958 parts of silver per 1000 was introduced to prevent the melting of sterling coin for plate, and two new marks, the *lion's head erased* and a figure of *Britannia,* replaced the lion passant and leopard's head crowned. The latter were re-introduced for sterling silver when

the higher standard ceased to be compulsory after 1720, although Britannia standard silver could and can still be made and marked accordingly.

During the first quarter of the eighteenth century 'bottom marking' was introduced for spoons, so that all the marks were closely grouped at the bottom of the stem near the bowl, although generally in the same order as before. After 1782, probably because of the thin stems of the period, spoons were 'top marked', that is marked at the top of the stem. Shortly afterwards all but makers' marks began to be struck simultaneously in a straight line and not singly as before. During the nineteenth century, and sometimes before, spoons with elaborate stems were marked on the bowl. In 1784 the *duty mark*, the monarch's head in profile, was added, and remained in use until 1890. From May 1821 until May 1822 an *uncrowned leopard's head* was struck on some spoons and after that period replaced the crowned leopard's head on all London silver. Thus frequently after 1784 and always after 1822 five marks should be found on a London spoon: the maker's mark, the leopard's head, the lion passant, the date letter, and the duty mark.

In the seventeenth century small spoons frequently carry only the maker's mark, and from the early-eighteenth century until 1782 the maker's mark and lion passant only, but the latter mark can be dated by its form. After 1782 the date letter is normally present on small spoons but the leopard's head or provincial town mark is frequently absent.

The earliest maker's marks were symbols. Generally during the seventeenth century and always after 1739, they included the initial letters of the maker's christian and surnames, except in the Britannia period when they showed the first two letters of the surname. The surviving registers at Goldsmiths' Hall, relating makers' names to their marks, date from 1697 onwards with one or two gaps, notably the Small Workers' Registers from May 1739 to July 1758, and the Large Workers' Registers from September 1759 to March 1773, which seriously affect the tracing of mid-eighteenth-century makers (see, for instance, Plate 25). Maker's marks are occasionally found to have been overstamped by another maker's mark, generally that of the retailing silversmith, a process which frequently renders both illegible. The same practice is sometimes found when provincial assay offices or centres remarked London work and *vice versa*.

Provincial marks

English provincial silver consists very largely of spoons, and some fine early spoons survive which carry marks presumed to be those of provincial makers or centres (see Plates 1 and 2). The earliest identifiable provincial makers' marks, however, and the surviving assay mark and date letter systems date from the mid-

sixteenth century onwards, the major manufacturing and marking centres being York (the earliest), Newcastle, Norwich, Exeter and Chester. During the late-sixteenth and seventeenth centuries many smaller provincial centres, notably those in the prosperous West Country, produced a large number of spoons of an individuality and variety of design unknown in London. Among these the marks of Taunton, Truro, Barnstaple, Bridgwater and Plymouth have been identified, but a great many spoons, especially those carrying makers' marks only, have still to be attributed. Many of these marks imitated the form or placing of London marks (see Plates 13 and 15).

In 1701, having been initially omitted from the Statute of 1696 introducing the Britannia standard, the assay offices at York, Exeter, Chester, and in 1702 Newcastle, adopted, by statute, the Britannia standard marks, as well as a town mark and date-letter system; and all the other centres quickly ceased production or marking. These and all later provincial marks were positioned as on contemporary London spoons. The lion passant and leopard's head crowned were used after 1720, as was the duty mark when introduced. In 1773 new offices were opened at Birmingham and Sheffield which changed their date letters in July. All the other offices except Chester closed during the following century.

It should be noted that genuine spoons of all periods, even those of London manufacture, can be found which are either unmarked or carry only makers' marks. This applies, in particular, to most spoons made before about 1500 and many in the sixteenth century, and during the rococo period among later spoons (see Plates 29 and 37). The diamond-shaped registered design marks found on some nineteenth-century spoons (see Plates 52 and 55) were used by the British Patent Office between 1842 and 1883 and protected the design from imitation for three years after the date indicated on the mark. A system of registered design numbers was used from 1839 until 1842 and after 1883. The registering designer, or, more frequently, the manufacturer can be traced at the Public Record Office, London. A key to the interpretation of these marks and the later numbers is given in Patricia Wardle's *Victorian Silver and Silver-Plate* (Herbert Jenkins, 1963).

Construction and manufacture

A spoon is usually composed of a bowl, a handle or stem, and, sometimes, a decorative finial or knop at the end of the stem. While very large spoons and spoons of novel type are sometimes made out of several pieces soldered together (see, for instance, Plates 21, 32, 38 and 45) the bowls and stems of English spoons of normal type, unlike many Continental examples, are almost

always formed out of one piece of silver. The only joints, often visible as a thin line of yellow solder, are those attaching the finial to the stem, with the exception of acorns and diamond-points, which are formed from the stem. These joints can be of three kinds: the V-notch joint (see fig 1) used on all London spoons after the early-sixteenth century and on a few before that date, the step or lap-joint (see fig 2), used on some early London spoons and on practically all provincial spoons, and the scarf-joint (see fig 3), which is usually limited to Onslow Pattern spoons (see Plate 37).

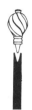
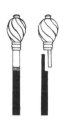

1 *V-notch joint;*
 front

2 *Lap-joint;*
 front and side

3 *Scarf-joint;*
 front and side

Before the nineteenth century the first stage in making a spoon, unless it had been cast, was probably to cut and hammer a piece of silver until it closely resembled the finished article but was still completely flat. Any relief decoration on stem or bowl (see for instance Plates 17, 27, 28) was then added by hammering the silver on a flat anvil, or swage, engraved with the desired design in intaglio. The bowl was then deepened by hammering it over a stake or into an appropriately shaped hollow made in lead, which did not damage any relief decoration, and the stem finally shaped, a process carried out after hall-marking during the eighteenth century as the distorted marks often show. The periodic heating needed to anneal the silver and keep it soft produced 'firestain' on the surface, a bluish tinge very difficult to remove and often present on spoons (see Plates 17, 22).

The manufacture of complete spoons by striking sheet-silver blanks between engraved steel dies under a mechanical press had begun by the late-eighteenth century, and largely replaced older methods from the early-nineteenth century onwards. Spoons carrying designs on the upper side of the stem only are described as 'single struck'; those on both sides as 'double struck'. This process, which still required a good deal of hand work, was superseded from the mid-nineteenth century onwards by one in which the blanks were passed between engraved rollers.

Spoon-making was a specialised trade for many silversmiths, for example, the anonymous sixteenth-century fringed S maker (see Plates 4 and 5), and several members of the Smith, Eley,

Fearn and Chawner families in the eighteenth and nineteenth centuries (see Plate 41). The manufacture of cast apostle and other finials, identical examples of which occur on spoons by different makers, was probably an equally specialised occupation (see Plate 3).

General history

The development of silver spoons up to the fourteenth century, which includes the largely twelfth-century Coronation Spoon, cannot unfortunately be discussed here, but some account of it

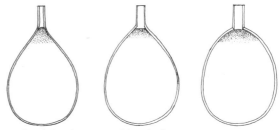

4 *Generalised development of bowl plan, 1450–1650*

will be found in the Bibliography. A specifically English type of silver spoon, characterised by a hexagonal stem, had probably emerged as early as the mid-fourteenth century, and it continued in use, with modifications, until the mid-seventeenth century.

The progressive development (see figs 4 and 5) from the earliest examples with their slim tapering stems and fig-shaped bowls, which drop at a steep angle from the stem, to the latest examples, with their wide and nearly flat untapering stems in line with level-rimmed and almost oval bowls, has been traced by Commander and Mrs. How (see Bibliography) and allows early spoons to be dated on form alone. With the exception of slip-tops and stump-tops (Plates 10, 20), all these spoons had some kind of knop at the end of the stem. This knop was nearly always gilt, but in a few cases the entire spoon was gilt. All the types of knop which appear with some regularity are described in Plates 1 to 12, the most common type being the seal-top and the most well known the apostle spoon. The latter is ideally, but

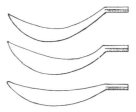

5 *Generalised development of bowl profile, 1450–1650*

extremely rarely, found in sets of thirteen, each figure being identified by the symbol it holds (see Plate 3 and page 14). Many other types of knop are recorded in contemporary inventories, and a very small number of these and some unlisted types have survived, including the wild man or 'wodewose', the architectural Gothic finial (both represented in the Victoria and Albert Museum), and the crest-top, shaped as the owner's crest.

Silver spoons were, in the medieval period, confined to rich households, but in 1577 William Harrison, in his *Description of England,* recorded among other signs of prosperity the exchange of 'wooden spoons into silver or tin' in the houses of yeoman farmers; a change reflected in the large number of late-sixteenth and seventeenth-century provincial spoons of good quality which have survived. In the sixteenth and seventeenth centuries spoons were customarily given at christenings, and also, presumably at funerals, as *memento mori,* and are sometimes appropriately inscribed. They are also frequently found pricked with initials, not uncommonly those of a married couple, and a date, which, in the seventeenth century, is often rather later than that of the spoon. Engraved crests, generally unidentifiable, are frequent from the mid-eighteenth century onwards.

The puritan type (Plates 13, 14), the earliest flat stemmed English spoon, overlapped with the last hexagonally stemmed spoons, and was succeeded in about 1660 by the trifid (Plates 15-19), which, with its flat stem and level oval bowl, was the first spoon of 'modern' type. Whilst references to specific uses do occur in early inventories, they are difficult to relate to surviving hexagonally stemmed spoons for these occur in a variety of sizes, although very small examples are thought to have been intended for children (Plate 10). The trifid period, however, saw the development, standardisation and proliferation of spoons for specific uses, some of them being new, such as teaspoons and mote spoons (Plates 18, 31) and others being of earlier origin, such as basting spoons (Plates 20, 21) folding spoons for travelling, and suckett or sweetmeat spoons with fork ends, not illustrated here. A growing standardisation of two chief spoon sizes, later known as tablespoons and dessert spoons, had been achieved by about 1700, perhaps encouraged by the introduction of the earliest, but still very rare, matching services of knives, spoons, and forks, forks still being a comparatively recent innovation. From this date it is possible to speak of spoons together with forks and sometimes knives, as 'flatware', the opposite of vessels or 'hollow-ware'. Dessert spoons, it should be said, are relatively rare until the latter part of the eighteenth century.

The short lived wavy-ended spoon (Plate 22), a development of the trifid, led on to the well known Hanoverian Pattern with its turned up stem, the standard type from about 1715 to 1770

(Plates 24-26). After about 1730 the rat-tail bowl back, which had descended from the trifid, was replaced by a wide variety of plain and decorated bowl backs, particularly on teaspoons, many of them influenced by the current rococo style. In addition, a number of spoons, particularly ladles and teaspoons, were made in a rococo manner more or less unrelated to the current Hanoverian type (Plates 29, 32). During the second half of the eighteenth century there was a further massive development and standardisation of new spoon types, including small ladles (Plate 37), caddy spoons (not discussed here) and a number of varieties more common in the nineteenth century, such as ice spoons (Plate 50). Services became considerably more common, and the range of pieces included was expanded (Plate 43).

The elegant Old English Pattern, with its stem turned down at the end (Plates 33-35) generally replaced the Hanoverian after about 1770 and was in turn largely superseded by the Fiddle Pattern shortly after 1800. The many types of decorated Fiddle Pattern, beginning with the Hourglass (Plate 43), form the main theme of nineteenth-century flatware designs (Plates 48, 52) but there were, in addition, a large number of spoons in naturalistic, revived historical, and other styles. It is interesting, however, that the Arts and Crafts movement and Art Nouveau had little general influence on spoon design (Plate 56). The standard spoon types become very large in the nineteenth century, and were the culmination of a trend towards increasing size which began in the mid-eighteenth century (Plates 25, 43). Among the new nineteenth-century types were round bowled soup spoons and the first coffee spoons to be appreciably different from teaspoons, both introduced towards the end of the century.

Foreign, particularly French, influence has from time to time profoundly affected English spoon design, notably during the Restoration, Rococo and Regency periods. In addition, more or less direct copies of foreign spoons were occasionally made before the nineteenth century and more frequently thereafter. These include sixteenth and seventeenth-century spoons with hoof ends, some of them based on the Dutch type shown on Plate 53, and the group of late-seventeenth-century York memento mori spoons made for the Strickland family and apparently based on Scottish disc-end spoons (Plate 40).

Out-of-period spoons also occur and have usually been made to complete old sets or as a traditional type. Some eighteenth-century church spoons, for instance, with pierced bowls for clearing the surface of the wine, were furnished with seal-ends, perhaps in imitation of older spoons they had replaced. Conversely, old spoons were sometimes brought up to date (see page 15), but it may be suspected that many such anomalous spoons have since been altered or have disappeared as uncollect-

able. From the medieval period onwards spoons of pewter and latten, and in the nineteenth century, Britannia Metal and electro-plated nickel silver, tended to imitate their more expensive silver counterparts, but with variations and unique types of considerable interest to the silver historian (see Bibliography).

Except for a few names drawn from early inventories, such as 'Wrythen Knop', the present names of spoon types are trade or historians' terms of comparatively recent origin. 'Old English' is a late-nineteenth-century trade term applied to spoons previously described simply as 'plain', while the term 'Hanoverian' was, according to W. J. Cripps, invented by the nineteenth-century antiquary Octavius Morgan, together with the since unadopted term 'Restoration' for the trifid. A set of dessert spoons 'with Threads and Shells' (Plate 41) appear in the Garrard Ledgers as early as 1756.

Fakes and 'restorations'

As in almost all collector's fields there are a considerable number of fakes. Complete spoons produced by casting from a mould taken from a genuine original can be very convincing but are fortunately rare (see Plate 57).

Far more common are fakes made by converting less desirable into more desirable types through reshaping or adding and removing elements. Apostle spoons, the most frequently faked of the knopped spoons, are generally made by adding a new finial to a reshaped later spoon or altered seal-top (see Plates 58, 59). Other knopped spoons are made in the same way, while slip-tops can also be produced by altering seal-tops. Among the conversions of later types we may note the engraving of plain trifids, sometimes to make up a set, adding rat-tails to later teaspoons, reshaping teaspoons into mustard spoons, converting any small spoons into mote spoons (see Plate 31), adding picture-backs to plain spoons (see Plate 28), and Onslow ends, or feather-edging to Old English stems, and reshaping Fiddle Pattern into Old English spoons. The best guard against conversions and indeed all fakes is a thorough knowledge of the appearance, feel and construction of correct spoons. Knopped and other early spoons which have been tampered with are frequently gilded all over to hide incorrect solder lines, on the stem for instance, and other signs of working. Contemporary conversions occasionally occur, as can be seen in the Garrard Ledger entries for 'turning back' in about 1760, presumably indicating the conversion of Hanoverian spoons into the newly fashionable Old English pattern.

Most spoons have needed straightening out and perhaps reshaping after long use, but many early spoons have undergone more radical 'restoration'. The bowl, the area most affected by wear, particularly at the front (see Plate 15), can be 'restored' by

hammering out, which produces a thin whippy bowl, by solder-
ing on a new portion, detectable by the yellowish solder line
(see Plate 6), or by complete replacement. Solder lines are also
frequently seen in repaired cracks near the stem. These indic-
ations can be hidden by electro-plating the whole with silver, a
process very hard to detect. Engraving can be 'freshened' and
finials re-tooled and gilded. Lost nimbi, particularly the pierced
variety, can be replaced, as can emblems, which sometimes are
removed and replaced with more desirable types.

Wear, to which spoons are particularly prone, greatly affects
their appearance and therefore their value. The collector should
avoid low-priced but poor spoons and acquire only those of the
best quality he can afford, even if it means limiting his collection
to a few fine examples.

Apostle spoons

The ideal set of 13 apostle spoons contains a figure of the Master
and twelve apostles. Their identifying emblems, elucidated by
Commander and Mrs. How in *English and Scottish Silver Spoons,*
are as follows: The Master is invariably shown with his right
hand raised in blessing, while in his left he holds the orb and
cross; St. John usually holds his right hand in blessing, while in
his left he holds the cup, and unlike all the others except the
Master is usually beardless. St. Peter carries the keys of heaven;
St. James the Greater the pilgrim's staff and, occasionally, a hat
or shell; St. James the Less, a fuller's bat with a club end; St.
Andrew a saltire cross; St. Bartholomew a flaying knife; St.
Matthias a halberd or pole-axe; St. Thomas a spear; St. Simon
Zelotes a saw; St. Jude a long or processional cross. St. Matthew,
before about 1570 is shown carrying the builder's square and
thereafter the tax collector's money bag. The three loaves
carried by St. Philip, which might have been taken for the
money bags, were exchanged for the short Latin cross at about
the same time. St. Paul, the apostle of the gentiles and the
Patron of the City of London, whose symbol was a sword,
frequently replaced one of the above, often St. Matthew. All
the apostles except St. John generally carry a book in one hand.
It is possible to confuse worn, broken, or poorly cast emblems,
particularly broken examples of St. Thomas's spear and the pro-
cessional cross of St. Jude, as well the flaying knife of St. Barthol-
omew, the sword of St. Paul and the short cross of St. Philip.
One St. Nicholas finial is known, made in 1528 and now in the
Bute collection. He wears a mitre and has a tub with three chil-
dren at his feet. A unique St. Christopher finial of 1518 is in the
Plunkett set. St. Catherine and St. John the Baptist finials occur
in contemporary wills but on no recorded English spoons. No
English examples of finials showing the Evangelists had been
found by Commander How.

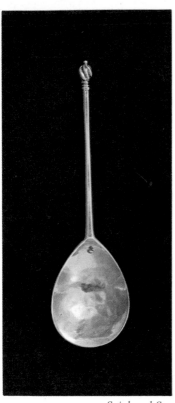

Spink and Son

Plate 1

Wrythen knop spoon; provincial, mid-15th century Maker's mark or town mark, in the bowl, a cross over an unidentified symbol in an orb and cross punch. 170 mm (6·7").

This form of spoon, the earliest that can be called specifically English, had probably emerged by the mid-fourteenth century and remained in use, with modifications, until the introduction of the 'modern' type in the mid-seventeenth century. The slim tapering stem is hexagonal, its facets being of equal width except near the bowl where the front and back facets are slightly flattened.

The long bowl is fig-shaped with a deep drop, not visible in the photograph, from the stem to the bottom of the bowl. The gilt finial, in this case a wrythen knop, is attached to the stem by a typically provincial lap-joint. Although examples made before the introduction of separate date-letter marks in 1478 are very difficult to date, it is clear that the type changed little until the end of the fifteenth century when the stem became thicker, heavier and less tapering, the front and back facets markedly wider and the bowl less steeply dropped and more pear-shaped (see Plates 2 and 3).

Most surviving spoons made before the sixteenth century have acorn or diamond point finials (see Plate 2). The 'wrethen knoppe', as it was described in contemporary inventories, had appeared by the early-fifteenth century but most of the rare surviving examples date from the late-fifteenth or early-sixteenth centuries and they had in general ceased to be made by 1550.

While the upper part of the stem of this spoon is in good condition the bowl is rather thin and worn in the base, a factor which can considerably affect the value of a spoon.

17

Plate 2

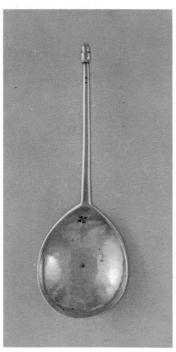

Spink and Son

Acorn knop spoon; provincial,
possibly Sandwich, *c.* 1500
Marked in the bowl with a cross
or serrated leaf. Hexagonal stem
shaped at the end into an acorn
finial. 137 mm (5·4″).

This spoon is typical of the acorn and diamond knopped spoons which
form the majority of surviving spoons made from the early-fourteenth
to the early-sixteenth centuries. In detail, however, it has features
characteristic of spoons made during the period of rapid formal
development in the years about 1500. Compared with the wrythen
knop (Plate 1) the bowl is more round-shouldered and is becoming
pear-shaped. The stem, although still tapered, has much wider front and
back facets, a development perhaps connected with the introduction, on
the back of the stem, of the separate London date letter in 1478. It is
interesting to note that the St John Apostle (Plate 3), also made in this
period of change, has a more advanced stem and in its weight and
proportions foreshadows sixteenth-century spoons, yet has a com-
paratively old-fashioned bowl shape.

The earliest English acorn knop and diamond point spoons can
probably be dated on form, to about 1300. Acorn knops appear in a
will of 1348 as twelve silver spoons with 'akernes' and are found in
several varieties, the type shown here being the simplest and most
common. Diamond points, shaped as a small four-faceted diamond,
appear as 'sponys with dyamond poyntes' in an inventory of 1487. Both
types had fallen from popularity by the early-sixteenth century,
although later examples, such as an acorn knop of 1585, were made
perhaps as replacements. These finials, being small, are most often
formed by shaping the end of the stem itself. A mark very similar to the
one on this spoon occurs on a cup of about 1500 at St Mary's Church,
Sandwich, and on an early-sixteenth-century wrythen knop spoon once
in the Walter collection.

Plate 3

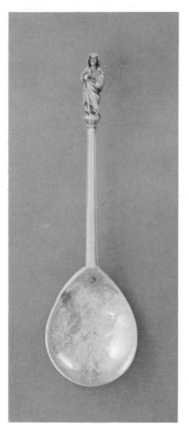

Apostle spoon, St John; 1498
Maker's mark a cypher (?). The
gilt figure attached to the stem by
a lap-joint. 185 mm (7·3″).

Spink and Son

Although, as in many other cases, the emblem, which was made
separately, has been broken off, the figure on this very fine early apostle
spoon has the youthful features and simple drapery characteristic of
St John. The emblem, the Cup of Sorrow, would have been held in the
left hand. The figure is related to a group of large well modelled
apostles on the Bishop Foxe crozier of about 1487 to 1501 at Corpus
Christi College, Oxford. These also occur, unaltered, on a few spoons
by a number of makers, including the Astor set of 1536. They are a
good illustration of the origin of such apostle figures, miniature copies
of monumental sculpture, as part of the medieval goldsmith's stock-in-
trade ready to be attached to any type of object. The bowl and stem of
this spoon reflect the changes of form which took place in the late-
fifteenth century (see Plate 1) while the narrow 'waisted' figure pedestal
is of the type found in the fifteenth and early-sixteenth century. The
lap joint, in this case clearly visible on the front of the stem, was
sometimes used on early London spoons although it is characteristic of
provincial products.

The earliest recorded document to mention apostle spoons was
written in 1494, but they were probably made at a considerably earlier
date, perhaps even as early as the fourteenth century, although no
recorded spoons can be dated earlier than the fifteenth. Three existing
part sets date from the latter century: the Beaufort set of six of about
1450 to 1478 at Christ's College, Cambridge; a dispersed set of 1490,
part of which was in the Jackson collection, and the earliest hall-marked
set; Lord Bute's set of six, hall-marked in 1499. At least five complete
sets of thirteen spoons (see Appendix) of the same date and by the same
maker are at present recorded: the set of 1527 once in the Dor collection
and now at the Huntington Art Gallery, five of the spoons being recent
additions; Lord Astor's set of 1536, consisting of the Virgin, rather than
the Master, and twelve apostles; The Swettenham Hall set of 1617, now
in the Francis E. Fowler Jr. Museum, Beverly Hills; the Lambert set of
1626 at Goldsmiths' Hall; the set of 1638 in the Jackson collection.
While most of the complete sets recorded in documents have been
dispersed, the lack of existing sets can also be explained by the theory
that a large number of spoons were owned singly, as is shown by the
rarity of Master spoons and the comparative frequency of St James,
presumably a popular christening present to children of that name, and
of St Paul, the Patron Saint of London.

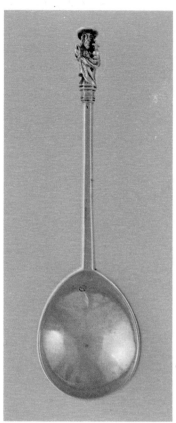

Spink and Son

Plate 4

Apostle spoon, The Master; 1527
Maker's mark a fringed S. The
finial, which retains traces of
gilding, is attached to the stem
with a V-notch joint. Length
about 183 mm (7·2").

This fine spoon is knopped with a figure of Christ or The Master, his
right hand raised in blessing, and carrying in his left hand the Orb and
Cross. In form and modelling it is a good early example of a figure type
which appears on the Bute set of 1499 and on the majority of apostle
spoons, repeated with increasing coarseness, as the moulds or models
wore out, until the mid-seventeenth century. A very similar Master
finial occurs in the Dor set of 1527, also by the fringed S maker (see
Plate 3). As on many apostle finials made from about 1520 to about
1580, the nimbus, which has been slightly depressed, is pierced in a ray
design. A concurrent type was the nimbus tooled in relief with rays, a
development of the earliest type of nimbus, which was engraved with
rays and sometimes placed vertically at the back of the head. All apostle
figures had nimbi, with the exception of a few early examples, notably
the Foxe Crozier group (see Plate 3), and some later provincial types,
such as those marked with A.B. and a castle. The emblem and nimbus
of this spoon, as on the majority of apostle spoons, have been soldered
to the figure.

From about 1525 until the early-seventeenth century the form of
spoons changed slowly, and this spoon is typical of the early years of
this period. The bowl is definitely pear-shaped and the stem is thick,
with wide front and back facets, but is still slightly tapered. The figure
pedestal, though thick and squat, is still a little 'waisted'. The drop from
the stem to the bottom of the bowl is still considerable (see also Plates
7 and 8).

The notable but anonymous maker who used the mark of a fringed S
was responsible for a comparatively large number of spoons of fine
quality, particularly during the 1520s and 1530s (see also Plate 5).

Plate 5

Lion sejant spoon; 1530 Maker's mark a fringed S. The finial shows traces of gilding. 171 mm (6·75″).

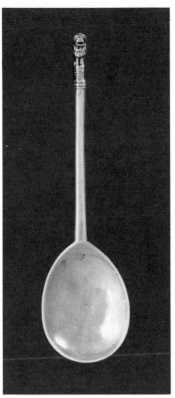

Spink and Son

The attractive lion sejant, consisting of a heraldic sitting lion, probably originated as a crest finial used by specific families. Three unusual fifteenth-century lion sejant spoons are recorded. Two of them, one of which is in the Victoria and Albert Museum, carry lions sejant *guardant* in which the lion is seated sideways and to the left with its head turned forwards, while the third carries a lion sejant *contourné*, sitting sideways and facing to the right. By the early-sixteenth century the only type found is that shown here, a lion sejant *affronté*, and it had in most cases lost any heraldic significance. A shield is sometimes attached to, or, in later examples, replaces the front legs. It is very occasionally engraved with arms, as on the '. . . twoo spoons of gold with twoo lions holding two Scutchions with the Kinges armes enameled at the endes . . .' listed in a royal inventory of 1549 and now lost like most of the royal plate. In early finials the front legs are well separated but on most sixteenth-century and later spoons they are joined and the space under the body frequently filled, as on this spoon. London lion sejant spoons had ceased being made by about 1600, but a number of notable provincial examples were produced in the late-sixteenth and early-seventeenth century, particularly in the West Country. These are often more simply formed and more vigorously tooled than London finials. Lion sejants changed very little in general form after the early examples and the finial models and moulds were, as in the case of other finials, re-used over many years.

The spoon shown here, with its thick unworn bowl, is in particularly fine condition. The V-notch finial joint is clearly visible at the front of the stem.

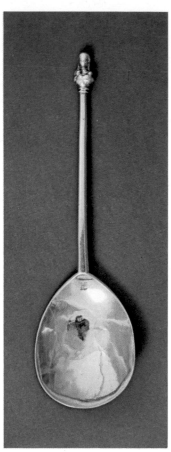

Plate 6

Maidenhead spoon; provincial, perhaps Ipswich, *c.* 1580. Marked in the bowl only with a Roman G in a shaped shield. The finial, which is attached to the stem with a lap-joint, retains traces of gilding. The bowl has been cracked at the junction with the stem and the lower half has been renewed. 165 mm (6·5″).

Ipswich Museum (No. R 1972-5)

The type of finial shown here, the head and shoulders of a woman, generally with the long hair indicative of a virgin, rising out of a calyx of leaves, probably originated as a representation of the Blessed Virgin Mary. Two spoons so described are listed in the Inventory of Durham Priory of 1446, but spoons *cum capitibus puellarum* appear in a York will of 1497, and 'maidenhead' was the most frequent name for such spoons in the sixteenth and seventeenth century, although references to the Virgin also occur. Surviving maidenhead spoons date from the fifteenth to the early-seventeenth century, during which period there was little, if any, change in the type of finial. As they are, in general, small spoons they are frequently difficult to date on form alone and the date assigned to this example is tentative, although the shape of the original upper portion of the bowl is typical of the mid- to late-sixteenth century.

The related but rarer 'Virgin and Heart' finial, a half-length female figure holding before her an object, generally supposed to be the Holy Heart, is usually found on small spoons of the early-seventeenth century, although one late-fifteenth-century example is recorded. The extremely rare full length 'Virgin and Child' finial is used as a substitute for the Master in the Astor Set of 1536, the same model also appearing on a spoon of 1577 in the Victoria and Albert Museum. Maidenheads are perhaps the rarest type to appear on the market with some regularity and fakes of all the above types, particularly by conversion (see Introduction) should be guarded against.

The G mark on this spoon, which has also been found on a number of pieces of Elizabethan church plate in the Ipswich area, may be a maker's mark or a town mark, as Gippeswic was the old spelling of Ipswich. Maidenheads, being small and light and their finials being unprotected by nimbi, are frequently as worn as the present example. The junction across the bowl of the old and new portions is clearly visible.

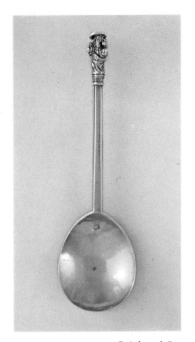

Plate 7

Apostle spoon, the Master; 1607
Maker's mark MH conjoined.
The finial, which retains traces of
gilding, carries a pierced nimbus.
The left side of the bowl has been
cracked and repaired. Length
about 178 mm (7″). One of a pair
with St. Peter.

Spink and Son

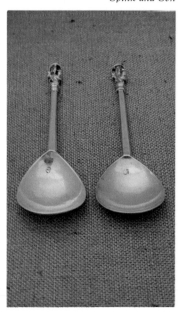

During the second half of the sixteenth century apostle finials tended to
become more rigid and rougher in detail, and the same model but with
different emblems soldered on, began to be used where before each
apostle had been separately modelled. The figure on the present spoon,
which dates from the end of the London period of apostle spoons,
should not only be compared with the finer example on the spoon of
1527 (Plate 4), but also with the much worse provincial figure of about
1650 (Plate 12). From the early-seventeenth century apostle finials
deteriorate considerably, even the emblems becoming indeterminate,
probably because of the use of old and worn models or moulds. The
pierced nimbus on this spoon is a little old fashioned for its date as the
solid type cast on top with the Holy Dove in relief, which may have
had an earlier origin on Master spoons, was generally adopted after
about 1580.

Apart from the almost taperless stem there is little change of form, in
the front view, to distinguish the 1607 Master from that of 1527, but
when seen together from the end, as in Plate 8, it is clear that in the later
spoon there is a considerably smaller drop from the stem to the bottom
of the bowl. This is an illustration of that general movement beginning
with the bowl of the fifteenth century dropping steeply from the stem,
and concluding with the almost flat bowls of the mid-seventeenth
century, which was one of the chief characteristics of the formal
development of hexagonally stemmed spoons. Apart from this tendency
the form of knopped spoons changed very little between the second
quarter of the sixteenth and second quarter of the seventeenth century.
After that date the change to a more oval bowl and flatter stem
accelerated, particularly after about 1650 under the influence of the
puritan form (see Plates 11 and 12). The repaired crack on the thin edge
of the bowl of this spoon is a typical example of the results of wear.

Plate 8

Left Apostle spoon, the Master;
1527. (see Plate 4).
Right Apostle spoon, the Master;
1607. (see Plate 7).

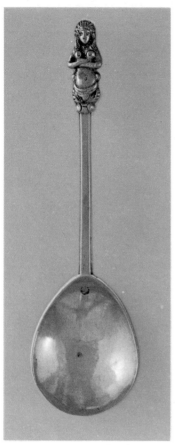

Spink and Son

Plate 9

Terminal figure spoon; Barnstaple, *c.* 1600 Maker's mark, in the bowl, a berry, possibly that of John Quicke. BARUM in monogram struck three times on the stem. Engraved on the bowl C/WT/1688 over another inscription. The gilt knop formed as a female demi-figure rising from an acanthus base. 193 mm (7·6″).

Spoons carrying female half-length figure finials appear to have been a West Country speciality. The rare type of finial shown here generally dates from the late-sixteenth to the early-seventeenth century. An equally uncommon parallel type, in which the figure is clothed, appears to foreshadow the more frequent Buddha Knop, which was apparently introduced in about 1620 and made until after 1660. The fully clothed half-length figure of the Buddha Knop with its strange head-dress has in the past been compared with several Indian deities, but a closer origin for all three types of finial can probably be found in the repertory of term figures found in Elizabethan and Jacobean woodwork as well as in the closely similar finials on contemporary Continental spoons and cutlery.

A number of spoons of the type shown here, stamped BARUM for Barnstaple on the stem, carry a maker's mark IQ or the berry mark of this example. IQ has been connected by Commander How with the Quycke family, two goldsmiths named Peter Quycke and a 'smith' John Quicke being recorded in Barnstaple, as well as with the berry mark, 'quicke' being the Devon word for a strawberry. A maker using the mark R.C, possibly also of Barnstaple origin, was responsible for a large proportion of the existing Buddha Knops.

This massive spoon is finer than many terminal figure spoons. Buddha Knops in particular are often very coarsely cast and finished.

24

Plate 10

Above
Slip-top spoon of small size; 1631 Maker's mark EH. Pricked FA on the back of the bowl and stem. 121 mm (4·8″).

Below
Slip-top spoon; 1630 Maker's mark D enclosing C. Engraved 1630 on the back of the stem and EC, in the same hand, at the top. 162 mm (6·4″).

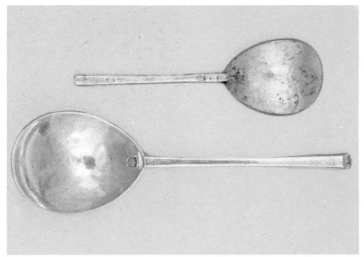

Private collection

Slip-tops are distinguished by a plain stem of hexagonal section, the end of which has been cut off at an angle. They are believed to have been the type described as 'slipped in lez stalkes' and 'slipped at thendes' in two late-fifteenth- and sixteenth-century inventories, 'slip' being a verb used in horticulture meaning to cut as in pruning.

The earliest dated English slip-top is hall-marked for 1487, but most examples date from the early to mid-seventeenth century, earlier spoons being rare. Unlike all other hexagonally stemmed spoons the stem thickens towards the end, markedly so in spoons made before the mid-sixteenth century. Apart from this characteristic there is very little change in stem form and dating on form alone can be difficult. Slip-tops usually carry one mark near the top of the stem, which in London is generally the date letter and in the provinces the maker's mark. The slip-top was, with the puritan, the commonest type of Commonwealth spoon, although it is by no means common now, and died out shortly afterwards except in a few large spoons. Fake slip-tops can be created by cutting off the ends of other less rare spoons, but these will lack the characteristic marking and thickening stem. Cast fake slip-tops are shown on Plate 57.

Small spoons dating from before the introduction of the teaspoon have been found in most varieties, but are very rare. The majority are believed to have been intended for children, but other types of small spoon were undoubtedly made, such as the 'little spoon for eggs' listed in Agnes Paston's inventory of 1479. The so-called 'moors-head' or 'cherub's-head' finial, not illustrated here, is generally found on spoons of small size. Small spoons are frequently found which have become pitted and corroded through having been buried, or in contact with corrosive substances.

Plate II

Above
Seal-top spoon (back); provincial, *c.* 1630 Mark T over M, struck in the bowl and three times on the stem. Gilt finial, the end pricked PS/MB/1689. 175 mm (6·9″).

Below
Seal-top spoon (front); 1655 Maker's mark I.I. Gilt finial, the end pricked RA. 179 mm (7″).

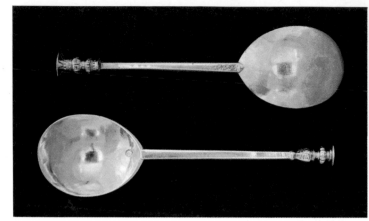

Private collection

The seal-top, the finial of which, in spite of its name, is never made to function as a seal, is the most common type of hexagonally stemmed spoon. The majority of seal-tops date from the seventeenth century, but even earlier examples are less sought after than other types of the same date. Unlike other spoons, it is possible roughly to date seal-tops by their finials, the forms of which are based on architectural columns or capitals. The earliest hall-marked examples, dating from about 1525 (the earliest recorded) to the 1540s, are formed as short Perpendicular Gothic capitals; a number of lobes or gadroons spring from a collar to support a flat hexagonal top. From the mid-sixteenth century until almost the end of the century the chief type, often rather light in construction, consisted of a Renaissance capital shaped as the upper portion of the finial of the London spoon shown here. After about 1575 the hexagonal end is generally replaced by a circular one. The London spoon is of the acanthus baluster type, based on a Renaissance column, which was the commonest type of seal-top from the late-sixteenth to the late-seventeenth century, when the last examples were made. Late examples are often very poorly constructed, wide puritan-type stems (see Plate 13) having been forced onto small finials made from old moulds. Notably large and heavy baluster seal-tops of various other forms, the commonest type replacing the present acanthus leaves with gadroons, were particularly popular in the late-sixteenth and early-seventeenth century. Some of the best examples were made in the West Country, the possible provenance of this fine provincial spoon which on form can be dated to about 1630. The lap-joint attaching the finial to the stem can clearly be seen as a darker portion. The comparatively wide stem of the late London spoon should be noted.

Hexagonal seal-tops are frequently so worn that they appear almost circular. Seal-tops are the commonest vehicle for fake finials, particularly apostles, the original finial having been completely removed or filed down (see Plate 59).

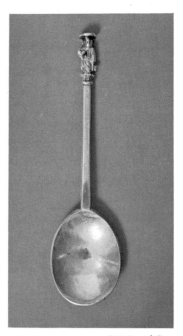

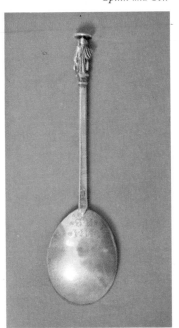

Spink and Son

Plate 12

Apostle spoon, St Peter (front and back); provincial, West Country, *c.* 1650 Marked in the bowl with crude replica of the leopard's head crowned and on the back of the stem with a flower and a crude lion passant. The bowl pricked M.M/R.B./1660 (the second 6 pricked over a 5). The figure gilt. 185 mm (7.3").

This spoon belongs to the 'London Forgery' group of provincial spoons. They are struck with poor copies of London marks, usually with curious lion passant shown here, and often with a spurious date letter and a sexfoil mark in the bowl, both missing here. The spoons, generally of mid-seventeenth-century date are of high quality and are thought by some authorities to have been made in the West Country, possibly in Bristol. Their misleading name originated in Sir Charles Jackson's description of the marks as forged London marks for 1637, but as can be seen on Plate 15 far better provincial 'forgeries' were produced.

In form this spoon is typical of those apostles made, mainly in the provinces, during the Commonwealth and Charles II period until the type died out. The drop from stem to bowl is very slight. The bowl itself is almost oval with rounded shoulders, and should be compared with the only slightly earlier pear-shaped bowl on Plate 11. The flattened hexagonal stem has wide top and bottom facets, the side facets having almost merged into one. The apostle is thin and flat in section but is much better cast and finished than many other contemporary examples and its emblem, the Key, more clearly visible than in most examples of this period. A similar, but of course finer figure appears in the Archbishop Parker set of 1566 now at Corpus Christi College, Cambridge. The nimbus or halo is cast on top with a Holy Dove or Saint Esprit in relief, as were most conventional nimbi after about 1580. In the provinces, however, large and flamboyant nimbi were made during this period, with decorated edges which are sometimes even engraved with initials. A nimbus of this type is soldered onto a very similar St Peter figure on a 'London Forgery' spoon once in the Ellis collection, which is marked in the bowl with a sexfoil. The seam of the provincial lap-joint is clearly visible in the rear view which also shows the junction of bowl and stem strengthened with a short V of metal, which was in use with slight changes from the early-sixteenth to the mid-seventeenth century.

27

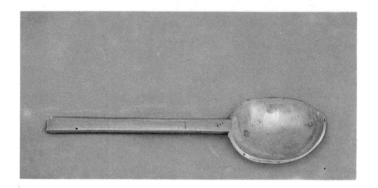

Plate 13

Puritan spoon; 1661 Maker's mark FP above a rosette. The date-letter struck near the top of the stem. Inscribed M. 188 mm (7·4″). Given to the Victoria and Albert Museum by the Church Commissioners.

Spoons of the puritan type are believed to have been introduced from Scotland, or more probably from France, and the earliest English examples appear to date from the 1630s. They became popular during the Commonwealth period, a fact which, together with their plainness, has given them their name. London examples ceased to be made in the 1670s, but provincial examples continued to be made for some time and they are now the most numerous kind. Puritan spoons are on the whole rare, being about as common as mid-seventeenth-century slip-tops.

They were the first English spoons to replace the medieval hexagonal stem with the modern flat form. The plank-like stem usually increases slightly in width towards the end, where it is abruptly terminated, but on some provincial examples this widening stem is very marked and is sometimes engraved or die-stamped in the manner of trifid spoons (see Plates 16 and 17). The bowl form was as revolutionary as the stem, being almost oval, a shape which on the Continent had begun to replace pear-shaped bowls in the previous century. Unlike earlier spoons there is no drop between bowl and stem, and the junction is strengthened by a short V-shaped tongue as shown on the trifids on Plate 16. One hall-mark, in London usually the date-letter, is commonly struck near the end of the stem as on slip-tops (see Plate 10).

This spoon was found in the roof of Farnham Castle in 1961 and is remarkably well preserved, the only wear being on the right hand side of the bowl. It is of the heavy gauge found on many mid-seventeenth-century spoons.

The notched-end puritan, distinguished by the notches at the end of its stem, was a type probably imported from France like the more common plain puritan (see Plate 13). This type of stem is used on the earliest dated English silver fork, made in 1632 and now in the Victoria and Albert Museum and on a matching spoon found at Haddon Hall and once in the possession of the Marquis of Granby. The origin of the trifid spoon probably lies in a development of this type, but it can only be traced in Continental spoons. This example illustrates how provincial puritans continued to be made well into the trifid period and were

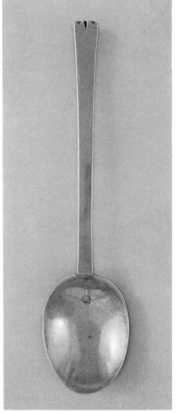

Bristol City Art Gallery
(No. N 7953)

Plate 14

Notched-end puritan; provincial, probably Bristol, c. 1670 Marked in the bowl BR in monogram. Pricked at the top of the stem R.C./P.C./1671. 190 mm (7·5″).

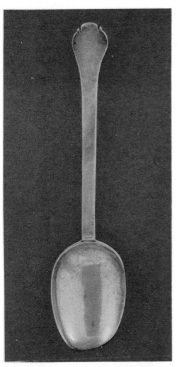

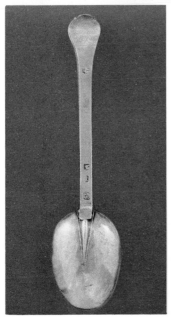

influenced by them, in this case in the form of the bowl. Other provincial examples adopted odd bowl shapes, including the 'shouldered' type shown on Plate 16.

The BR mark, which is identical to the one used at the Bristol mint in 1643-5, is probably the mark of that city. A few spoons, recorded examples of which date from about 1600 onwards, carry this mark, usually in association with a flower or star mark on the stem. A seal-top example from about 1640 can be seen in Bristol City Art Gallery.

Plate 15

Trifid spoon (front and back); provincial, *c.* 1680 Marked on the stem with a leopard's head crowned, lion passant, and a Gothic letter, also repeated at the top of the stem. Pricked on the stem A.B/1678. Length about 203 mm (8").

The trifid, the earliest spoon of modern form, is characterised by a flat stem which widens at the end where it is divided into three sections by two incisions. On examples of early type such as this one the increase in width is sudden, the central lobe is wide and the stem is turned up sharply at the end. On later examples the widening of the stem is more gradual and the central lobe is narrow and less sharply upturned (see Plates 18 and 19). The bottom of the stem, thickest at this point, turns downwards in a tight curve to meet the bowl to which it is joined by a fully developed rat-tail, although certain provincial and odd-sized spoons lack this feature (see Plates 16 and 18). The type of rat-tail shown here is the earliest; it was followed by examples with beading and scrolls down the centre and by elaborate 'lace-back' and engraved types. The stem was frequently decorated as well (see Plates 16 to 19). The egg-shaped trifid bowl with its level rim altered little throughout the period.

This entirely new form of spoon, which was to last until about 1700, was probably copied from French examples imported at the time of the Restoration, but did not become common until the 1670s. The earliest recorded English trifid dates from 1662. But for a more pronounced swelling at the top of the stem it is very similar to the present example which may, in form, be regarded as typical of the early undecorated trifids. Upon the introduction of the trifid, possibly because of the rat-tail, hall-marking in the bowl was abandoned for most rat-tailed spoons and the stem marking sequence adopted which was to last until 1782. London trifid marks should be evenly spaced up the stem although some early examples are marked as puritans. The provincial marks on this example, which are possibly East Anglian, are clearly intended to imitate London hall-marking but as on a number of provincial trifids the marks are spaced as on puritan spoons (see Plate 13). A very worn and thin bowl as on this piece can considerably affect the value.

Plate 16

Six trifid spoons; West Country, possibly Cornish, c. 1674 Maker's or town mark AW in a beaded circle only, struck in the bowl and three times on the stem. Pricked B.I.M/1674. 190 mm (7·5″).

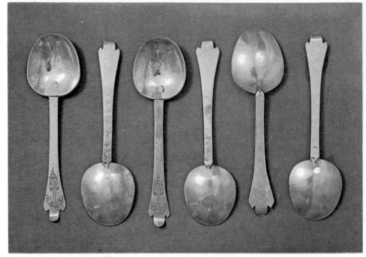

Spink and Son

Plates 15, 17 and 19 show trifids of the three main types, but a number of other types were also made, particularly in provincial centres, which are of considerable interest. Many are found to retain, like the spoons shown here, features of the puritan spoon, such as the short V-shaped rat-tail, the 'wide-shouldered' bowl and the flat profile (see Plates 13, 14). Conversely, provincial puritans, which continued to be made well into the trifid period, sometimes used the widening trifid stem. A wide variety of engraved and punched ornament and stem shapings were used. Some spoons made in Bridgwater carry a stamped medallion of Charles II at the top of the stem, a practice not unknown in base metal spoons but very rare in silver.

Sets of spoons, especially of two or four, are slightly more common in trifids than in earlier types, but sets of six are very rare. Single provincial examples of average quality are not uncommon.

Although pricked dates should be regarded with caution the date on these spoons, judging by their style, is close to their date of manufacture.

Plate 17

Trifid 'lace-back' spoon (front and back); provincial, West Country, about 1700. Maker's mark RS with an anchor between, struck three times on the stem; possibly that of Richard Sweet of Chard. Pricked I.C/D.S/ 1701. 200 mm (7·9").

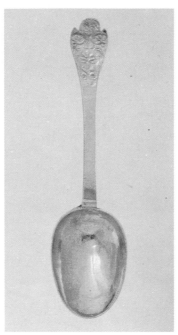 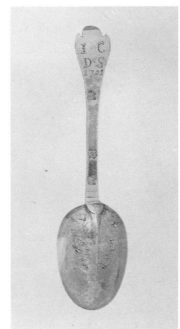

Private collection

The 'lace-back', so named because of the lace-like scrolling foliage die-stamped in relief on the back of the bowl, is perhaps the commonest and best-known type of decorated trifid. The top of the stem has usually been stamped with a similar design at the front. Another type of bowl decoration, consisting of a flame-like pattern engraved or raised in relief, is much rarer and has been faked. This use of elaborate decoration on the backs of bowls may have been connected with a fashion for laying spoons with the concave side of the bowl towards the table in the Continental manner. The lace-back had appeared by the late 1670s and like most other trifid types continued to be made until about 1700, good examples reaching a high degree of refinement in design and execution.

The distinctive and rather crude decoration on this spoon has been found on a number of spoons carrying 'S' surname maker's marks. Through the researches of Mr. T. A. Kent they have been attributed to members of the Sweet family who worked in several West Country centres. A number of RS and anchor spoons are pricked with dates around 1700 and although this spoon could on form be dated at about 1680, its pricked date is probably close to the date of manufacture.

Traces of fire-stain are clearly visible on this spoon. (See Introduction.)

Plate 18

Above
Condiment spoon; *c.* 1680
Maker's mark only, at the base of
the stem; FG above a mullet,
probably that of Francis
Garthorne. Heavy trifid stem and
a thick deep bowl with a short
plain rat-tail. 96 mm (3·8″).
Private collection

Below
Two teaspoons; *c.* 1685 Maker's
mark only, RS above a mullet.
Scratch engraved trifid stem of
light gauge. 106 mm (4·2″).
Private collection.

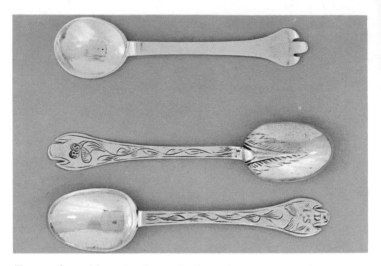

Tea was first sold at a London coffee-house in 1657. It was taken up
shortly after 1660 by the court of Charles II, and from about this date
it became rapidly more popular. Small light spoons such as the pair
shown here are now usually called teaspoons but they were probably
also used for coffee and chocolate, the other new and fashionable
beverages of the time. Such a variety of uses for teaspoons is supported
by the 'six gilt coffy spoons' mentioned in an inventory of 1703 and an
inventory of 1721 which does not distinguish between 'Tea or Sweet-
meat spoons'. Francis Buckley has suggested that spoons of 'toy' size
were used for tea (see Plate 36). Teaspoons imitated the larger spoons
except for an unusual variety having a wavy-ended stem (see Plate 22)
with a twisted central section. Examples of this type, which was also
made on the Continent, have been found which date from 1703 and
about 1722. Teaspoons and other small spoons made before 1782 are
very seldom fully hall-marked. Until the early-eighteenth century they
often carry only a maker's mark. After that time and until 1782, the
maker's mark and lion passant were struck on the back of the stem near
the bowl, such spoons being referred to as 'bottom-marked'. Teaspoons
made before the 1730s are very rare and this has led to a considerable
number of fakes (see Introduction).

The term 'condiment spoon' is given to a rare type of small spoon of
heavy construction with a deep round or oblong bowl often lacking
a rat-tail. One by the maker FG has been found in a blind caster of the
type generally supposed to have been used for mustard, also by FG. A
'little mustard spoon' is mentioned in a newspaper of 1678.

Existing condiment spoons appear to be restricted to the trifid type,
and what sort of spoons were used in mustard pots and casters until
about 1750 is open to conjecture, but they may have resembled long-
stemmed teaspoons (see Plate 36). A 'mustard cup with lid and spoon' is
listed in an inventory of 1721.

Plate 19

Trifid spoon; 1692 The maker's mark has been obliterated by the engraving, but the matching knife and fork are marked TT crowned. Silver-gilt. Both sides of the stem finely engraved with scrolling stems of foliage and cupids on a hatched ground. Engraved rat-tail bowl. 198 mm (7·8").

Trifid spoon; 1693 Maker's mark illegible. Silver-gilt. The engraving is identical on both sides of the stem. Engraved grooved rat-tail bowl. A matching fork is similarly marked. 184 mm (7·2"). *Private collection.*

Marrow spoon; *c.* 1695 Maker's mark obliterated. Silver-gilt. The top of the central portion of stem is also engraved, and the end hollowed out to form a scoop. Engraved double rat-tail bowl. 185 mm (7·3"). *Private collection*

Marrow spoon; 1695 Maker's mark T.Z crowned above a mullet. Silver-gilt. Both sides of the central section of the stem are engraved and the end hollowed out to form a scoop. Engraved rat-tail bowl. 149 mm (5·9").

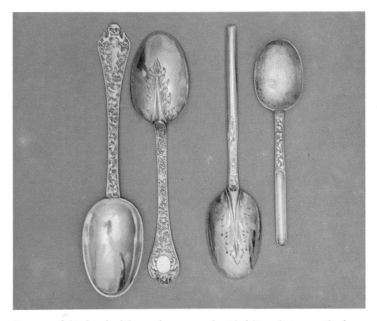

Spoons of this kind, elaborately engraved with foliate designs and often gilt, had appeared on the Continent by the 1680s. English examples generally date from the 1690s, and are the finest spoons of the trifid type. Wavy-ended examples of about 1700 are also known (see Plate 22). Rather coarser engraving sometimes known as 'scratch engraving' and often composed of overlapping leaf patterns as shown here on the larger marrow spoon, was popular on teaspoons and other small flatware. Many of the folding spoons used in travelling sets were gilt and engraved in this manner (see Introduction). The trifid end of the largest spoon, with its typically small centre section, is characteristic of this late period, although other types with much less pronounced notches continued the trend towards the wavy-ended type (see Plate 22).

The earliest examples of marrow spoons, which seem to have preceded marrow scoops (see Plate 23), date from the 1690s, although a marrow fork of about 1670 is recorded. The scoop end was used to extract the marrow from beef bones, then considered a delicacy. The type was made into the nineteenth century and occurs in all sizes of spoons, from mote spoons (see Plate 31) to large serving spoons, some of the latter being also provided with pierced straining bowls. A rare serving spoon example of 1706 with a plain bowl is known. The hallmarks on spoons of this type have frequently been disturbed or obliterated by the engraving. The makers TZ and TT, the latter mark being ascribed to Thomas Townley or Tucker, were prolific spoonmakers during this period.

These spoons illustrate the move towards the table and dessert spoon sizes which became standardised early in the next century.

Plate 20

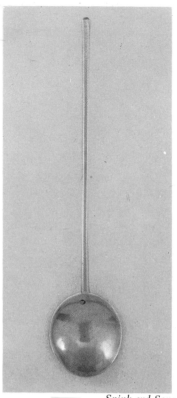

Basting spoon, stump-top; 1688
Maker's mark I.S. below a
coronet. Marked with a leopard's
head crowned in the bowl.
Hexagonal stem. 349 mm
(13·75″).

Spink and Son

Large cooking and serving spoons of silver, now commonly called
basting spoons (see Plate 21), were probably made from early times, and
amongst the earliest existing examples is a Norwich spoon of about
1600 formed as a greatly enlarged slip-top 332 mm (13·1″) long.

Slip-top and stump-top basting spoons were made until almost the end
of the seventeenth century, well after such types had ceased to be used
in smaller spoons, but the commonest late-seventeenth-century basting
spoon is flat stemmed and generally of trifid form. Such spoons usually
have round or rounded bowls which may be partially or completely
pierced with round holes for straining. Even late trifid examples
frequently lack a developed rat-tail having retained the older short
junction, and consequently are often marked in the bowl in the old
way. Utilitarian spoons of this kind tend to produce specialised types,
among which may be noted a straining spoon of 1679 with a two-
pronged fork at the end of the stem. All these spoons are rare or very
rare, unlike the comparatively common tubular handled basting spoons
which rapidly superseded them after about 1690 (see Plate 21).

The stump-top was a European form, and the very rare English
examples occur during most of the seventeenth century. They are
generally characterised by octagonal stems terminating in a rounded or
pyramidal form. Like puritans and slip-tops they frequently carry one
of the hall-marks near the end of the stem.

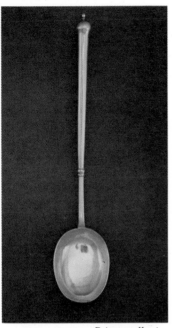

Plate 21

Basting spoon; 1699 Maker's mark of Lawrence Jones. Britannia standard silver, fully marked on the bowl, and, except for the date letter, on the back of the stem. Hollow tubular handle with a solid lower section. The small hole at the top of the handle probably served as a blowhole when the two sections of the handle were being soldered together. The plain rat-tail is soldered to the separately made bowl. 333 mm (13·1″).

Private collection

This form of basting spoon, with its hollow tubular stem and oblong bowl, was the most usual type from about 1690 until about 1715, after which date basting spoons were generally enlarged versions of table-spoons. Provincial and Irish examples, however, continued to be made. The type is occasionally found with a turned wooden handle. An example of 1713 by Isaac Davenport is known. It is 16 inches long and has half its bowl perforated for straining. The modern term 'basting spoon' suggests a kitchen use, but such large spoons were probably intended to be general purpose cooking and serving spoons (see also Plates 20, 24 and 43). Examples of the type shown here in the Royal Collections and in the Chester Corporation Plate were used for soup, the former being listed as 'Two large Plain Ladles for Plum Broth'. A French example is associated with a punch bowl, and the 'porridge ladle' ordered by John Hervey, 1st Earl of Bristol, in 1695 was perhaps of the same type.

This spoon, an early example of its kind, is very well hall-marked and in excellent condition. The marks of the raising hammer are clearly visible on the bowl (see Introduction). The bowl and stem of this form of spoon are often both hall-marked as they have been made separately, but the date letter is frequently omitted from one portion. The hollow tubular stems generally terminate in a finial, but can also be found in other forms, such as the type with the end cut off diagonally like a slip-top.

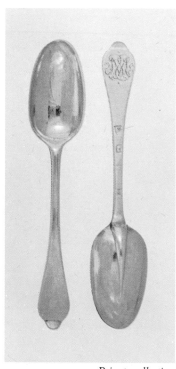

Plate 22

Pair of tablespoons; 1707. Maker's
mark of Isaac Davenport.
Britannia standard hall-marks.
Wavy-ended stem, finely en-
graved with MS in monogram.
Plain rat-tail. 202 mm (7·9″).

The wavy-ended or dog-nose spoon, characterised by its distinctively
shaped stem, is a transitional form between the trifid and the Hano-
verian. The first English examples date from the early 1690s. They
became more frequent after the introduction of the Britannia silver
standard in 1696 and the last examples were made during the second
decade of the following century. Before about 1700 the lower end of
the stem was flat in section, as on the contemporary trifid spoons (see
Plate 19), and the rounded shape shown here, which was also used on
Hanoverian spoons, was adopted after that date. On the later type the
upper part of the stem becomes markedly thinner in section and is
sometimes without an upward turn at the end. A less common variety
has a pronounced and often rather crude ridge down the front of the
stem, evidently related to similar ridges on early Hanoverian spoons
(see Plate 24). On some large spoons the very end of the stem thickens
to form a sort of button. On the bowl a double (see Plate 19) or plain
rat-tail was used. The latter type had appeared on trifids by 1690, and
later became usual on early Hanoverian spoons. The bowls of the
spoons shown here, deep and narrow in marked contrast to those of
trifid spoons, are representative of the type in use during the first thirty
years of the eighteenth century. These examples, like many Britannia
standard pieces, are characteristically heavier than many trifids of
similar size, and carry traces of their original fire-stain (see Intro-
duction).

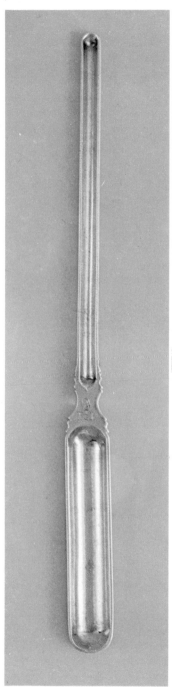

Plate 23

Marrow scoop; Scottish, Aberdeen, *c.* 1730 Maker's mark of George Cooper. Made of five parts soldered together. 197 mm (7·75″).

The marrow scoop seems to have appeared in the early-eighteenth century, rather later than the marrow spoon (Plate 19), and both types were made into the nineteenth century as part of the usual complement of flatware. The present example is of a very rare and distinctive Scottish type particularly associated with Aberdeen. The five-part construction is very unusual for a marrow scoop.

The scoop ends of English marrow scoops are generally of more equal length although of unequal width, and are connected with a plain stem. The bowls and stems of the earliest examples are sometimes faceted, while the early Hanoverian examples have flat stems. Thereafter the stems follow the section of contemporary spoons. Some examples have bowls facing in different directions. Single-bowled scoops were also made including a very small example with a teaspoon stem.

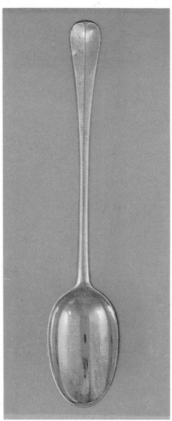

Spink and Son

Plate 24

Serving spoon; 1720 Maker's
mark of William Penstone.
Hanoverian stem and a plain
rat-tail on the back of the bowl.
About 350 mm (14").

Large eighteenth-century spoons, like their earlier counterparts (see
Plates 20 and 21) are now often called basting spoons, but a spoon of
the type shown here is listed in the old inventories of Clare College,
Cambridge, as a soup ladle. They were, like their predecessors, probably
general purpose serving and cooking spoons and in the eighteenth
century were most frequently called ragout spoons, ragout being spelt
in various ways.

By the early-nineteenth century the usual term was the anglicized
phrase 'gravy spoon' (see Plate 43). The Clare College spoon was
made in 1708-9 by Lewis Mettayer of London, and is an early example
of the Hanoverian Pattern which was introduced in the first decade of
the eighteenth century and remained the most popular spoon type until
about 1770. It is distinguished by its stem, the rounded end of which is
turned up when the spoon is laid with the concave side of the bowl
upwards (see Plate 26). On early examples such as this one the stem is
turned sharply upwards and is ridged on top, forming two hollows on
either side. On later examples these features gradually became less
marked (see Plate 25).

Until about 1730 Hanoverian spoons carried rat-tails of the simple
type shown on the wavy-ended spoons on Plate 22, and their bowls
were generally rather narrow and deep. After that date bowls tended to
become wider and various types of drop replaced the rat-tail (see Plate
27). The Hanoverian type was, in its essentials, adopted in most Euro-
pean countries at the same time as it appeared in England, and some
writers have seen it as a natural development of the wavy-ended type.
It may have been introduced by immigrant French Huguenot silver-
smiths. Rat-tail Hanoverian spoons are the earliest type of which it is
still possible to collect a matching set, and they are consequently much
in demand. Teaspoons are rare and have been faked. A particularly fine
silver-gilt 76-piece Hanoverian dessert service of 1713 by David
Willaume is in the Assheton Bennett Collection, Manchester.

Plate 25

Hanoverian tablespoons *Left to right*

1735. Maker's mark S·W, perhaps for Samuel Wood. 198 mm (7·8").

1744. Maker's mark J·W in script. 203 mm (8").

1746. Maker's mark of Samuel Roby. 204 mm (8·1").

1750. Maker's mark R·H. 203 mm (8").

Exeter, 1758. Maker's mark of James Strang. 200 mm (7·9").

1761. Maker's mark W·L. 208 mm (8·2").

1773. Maker's mark of George Smith (Fallon No. 3), probably his first mark, not recorded at Goldsmiths' Hall. 211 mm (8·3").

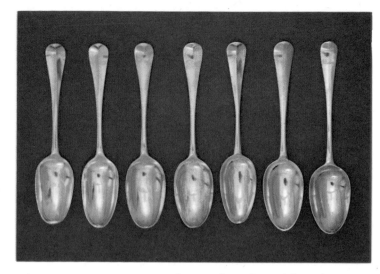

The Hanoverian spoon remained essentially unchanged from about 1730 until the last examples of the type in the 1770s and 1780s. Gradual changes in bowl and stem, however, occurred throughout the period and the spoons shown here illustrate these changes. They are not, of course, representative of all spoons of their date. The bowls of the two earliest examples are of the deep oblong form which had been in use since the start of the century. By 1746 the bowl has become wider and more rounded leading gradually to the characteristic egg-shaped bowl of 1761. The stems of the two earliest spoons are thick and sharply upturned at the end, and have a marked ridge down the front, although on the later example the ridge forms no hollows on either side (see Plate 26). By 1746 the ridge has shrunk to the end of the stem which is, however, still thick. By 1761 the ridge is very perfunctory and the stem does not thicken at the end. Although all the stems, with the exception of the example of 1773, are the same width at the top, they gradually lengthen in proportion to the bowl and the overall length of the spoons increases. The spoon of 1773, which has been influenced by the fashionable Old English spoons of the period (see Plate 35), is quite unlike the earlier examples. The Exeter spoon is a good example of a partially retarded provincial form.

Plate 26

Front Tablespoon; 1735 Maker's mark S·W, perhaps for Samuel Wood. 198 mm (7·8″). See also Plates 25 and 27.

Back Tablespoon; 1746 Maker's mark of Samuel Roby. 204 mm (8″). See also Plates 25 and 27.

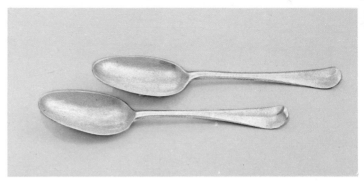

This Plate clearly shows the characteristic upturned stem of the Hanoverian spoon. The earlier example is more sharply upturned than the later, but after the mid-century Hanoverian profiles hardly change. The long ridge which forms two hollows on the top of the stem is visible on the earlier spoon, as is the short ridge and convex section stem of the later example. The difference in bowl shapes should also be noticed.

Plate 27

Backs of bowls *Left to right*

Single drop; 1791 Maker's mark of George Smith and William Fearn. A Paris Import Mark for 1819-38 near the bowl.

Double drop; 1735 Maker's mark S.W, perhaps for Samuel Wood (see Plates 25 and 26).

'Detached shell'; 1746 Maker's mark of Samuel Roby (see Plates 25 and 26).

'Attached shell'; 1754 Maker's mark of James Tookey.

'Rococo shell'; 1750 Maker's mark R.H. (See Plate 25).

Late single drop; 1768 Maker's mark probably that of Thomas and William Chawner. A sauce ladle.

Double threaded Fiddle Pattern drop; 1845 Maker's mark of George W. Adams.

Diana mask, back of Stag Hunt Pattern; 1855 Maker's mark of George W. Adams (see Plate 44).

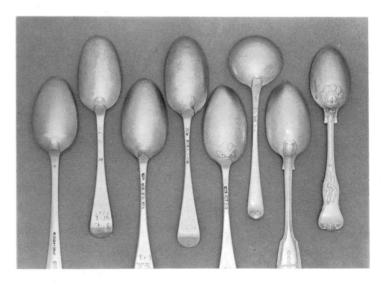

The single drop has been found on a French spoon of about 1700. It was occasionally used on English spoons after 1715, but did not entirely supersede the rat-tail until about 1730, by which time the double drop had also been introduced. These two drops are the commonest form of 'heel', as it was called in the eighteenth and nineteenth centuries, to be found on the larger Hanoverian and Old English spoons, although the double drop is less commonly found on the latter type. In shape they

hardly changed throughout the eighteenth century, although the late double drops are usually less well formed. A different type of single drop, formed as a long strap struck with a cross ridge at the end, occasionally occurs about 1750, but is generally found on Old English spoons from the 1760s onwards. A longer and entirely plain version, not shown here, was also popular, particularly, it would appear, on small spoons. This form of long drop was possibly influenced by the type on the threaded Fiddle Pattern, which was imported from France. The earliest example of the more decorative types of heel which were widely used on spoons from the 1730s to the 1790s is probably that which may be described as the 'detached shell', a well-formed naturalistic shell which is more or less detached from a simple single drop and which occurs from 1736 onwards. The 'attached shell', which springs from the drop and probably dates from the late 1730s has by about 1750 become large and flamboyant on many spoons, somewhat resembling a palmette. The 'rococo shell', which probably dates from the 1740s, remained in use until about 1780, occurring on both Hanoverian and Old English spoons. It was often combined with a rococo scroll, an equally popular motif (see Plate 28). Decorative heels of this type, which are known as fancy-backs to collectors, are most common on teaspoons and less common on larger spoons, being rarest on dessert spoons. This plate clearly shows both bottom-marking and the bowl marking adopted in the nineteenth century for spoons with decorated stems.

Plate 28

Left to Right

'I love Liberty'; *c.* 1770 Maker's mark probably that of Philip Roker. 127 mm (5").

'Rococo scroll'; *c.* 1760 One of a pair by William Tant. 114 mm (4·5"). *Private collection*

Prince of Wales's Feathers; *c.* 1760 Maker's mark probably that of Ebenezer Coker. 115 mm (4·5"). *Private collection*

'Rococo shell and scroll'; *c.* 1770 One of a set by Hester Bateman overstamped by another (see Introduction). 122 mm (4·8"). *Private collection*

Neo-classical husk design; *c.* 1770 Maker's mark of George Smith. 119 mm (4·7"). *Private collection*

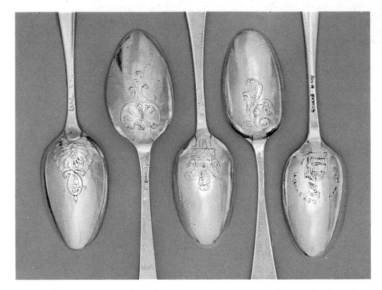

These five teaspoons, all with Hanoverian stems, are fine examples of the picture-back and fancy-back die stamped bowl decoration which was particularly popular on teaspoons from the 1750s to the 1770s, although examples dating from the 1730s to the 1790s can be found. Larger spoons with this decoration are rarer. Fancy-backs carry conventional designs of shells, scrolls and such designs as the rare neo-classical pattern shown here (see also Plate 27). Picture-back designs are more representational, the earliest being perhaps the spray of flowers design dating from 1738, but most picture-backs date from about 1750 onwards. The majority of the twenty-five designs recorded by Commander How (see Bibliography) are drawn from the conventional rococo and neo-classical decorative repertoire, only a few being of the topical or political nature which is sometimes claimed. The Prince of Wales's feathers design, for instance, became a common decorative device during the second half of the eighteenth century and any topical significance and dating given on the basis of this design should be treated with caution. The rare 'I Love Liberty' design, however, with the words above a released bird sitting on its cage, is a well attested reference to the celebrated case of John Wilkes, the same symbol being found on Wilkes seals and glasses. Support of Wilkes's cause became national after his imprisonment in 1768, and on his discharge in 1770, even Parson Woodforde's village of Castle Carey celebrated it: 'The Flagg on the Tower had on it Liberty and Property, the small one had on it Mr Wilkes's Head and Liberty'.

Commander How's list of picture-backs is not exhaustive and several new types have since emerged, one of which is certainly of Jacobite significance. Very clear strikings should be inspected for consistent wear as they may have been made recently.

Plate 29

Five teaspoons; 1750–60 Maker's mark only, J or T.D in script below an acorn. Cast and chased with leaves, a flower, a ladybird and a caterpillar. From a set of sixteen (only six of which are marked) and a pair of sugar tongs, in a contemporary box. Length about 120 mm (4·7").

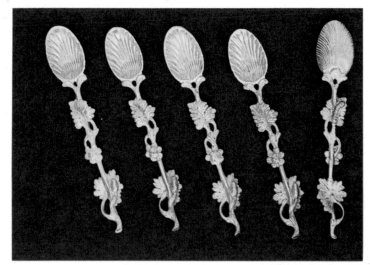

Thomas Lumley Ltd.

These teaspoons, which also occur in a variety having a leaf-shaped bowl, reflect that rococo interest in precisely imitated natural forms which was current from the late 1730s, and which in larger pieces of silver was often expressed by taking casts directly from nature. Most of the many varieties of naturalistic spoons are teaspoons using leaf, flower, and sometimes insect motifs and they can probably be identified with the 'Leaf teaspoons' mentioned in the Garrard Ledgers of 1748 to 1750. Precise dating is difficult as they are often unmarked or bear, as in this case, only an unidentified maker's mark, but the type is generally believed to have begun by the early 1740s, and had probably ceased being made by 1770. They are related to a type of mid-eighteenth-century spoon with a flattened stem of swirling foliage and to the 'whiplash' stem, which probably occurs as early as 1735 (see Plate 38).

These examples may be ascribed to a date towards the end of the period, while the leaf-bowled examples of the type, which are usually better cast, may be dated rather earlier. At least one very rare political type exists; two rosebuds spring from its leafy stem handle, symbolizing the two Stuart Pretenders (cf. Plate 30).

Matching sets of naturalistic teaspoons, boxed or unboxed, are rare. Both spoons and sugar tongs of this type were very popular during the nineteenth century (an example of 1814 is known), a fact which should be considered when dating unmarked specimens (see also Plates 49 and 51).

Plate 30

Left to right

Two teaspoons; 1739–45
Maker's mark of Jessie Macfarlane,
who registered her mark in 1739.
The stem is stamped with masks,
shells, rosettes and scrolls on a
matted ground. The bowl
stamped with a 'detached shell'
drop. 115 mm (4·5"). From a set
of six.

Teaspoon; London? About 1750
Maker's mark W.C or G. The
stem cast or stamped with a cupid
among scrolls and festoons, on a
matted ground. The back of the
acorn-shaped bowl is stamped
with a rococo shell in relief within
engraved foliage. 108 mm (3·9").

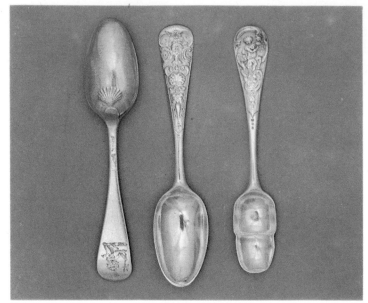

Private collection

From about 1750 the stems of some teaspoons and a few larger spoons
were decorated with stamped or cast ornament in relief, usually in
combination with a picture-back or fancy-back bowl, such as the
'polished tea spoons with a shell heel and flowered handle' mentioned
in an advertisement of 1751 (see Plates 27 and 31). Earlier examples are
very rare. The stem of a dessert spoon of about 1725 in the Ashmolean
Museum, Oxford, is cast in relief with the scrolling ornament in the
style of the French designer Jean Berain (1640–1711) which was so
popular at that time. The earliest spoons shown here display similar but
simplified Berainesque ornament as well as the 'detached shell' heel
characteristic of the early 1740s (see Plate 27).

Spoons with acorn-shaped bowls, which are believed to have had a
political meaning, are very rare. The oak was a symbol of peculiar
significance to the Jacobites, reminding them not only of the Boscobel
Oak in which Charles II eluded capture, but also of the oak which was
the emblem of the Stuarts. It is possible that spoons of this type were
made for the Jacobite Society of London, but it is equally likely that
they were used by private individuals as an expression of their political
sympathies. This early, heavy and well-finished spoon is a particularly
fine example. Copies of rococo teaspoons of this type were legitimately
made in the nineteenth century, but they are usually easily recognisable.

Plate 31

Top to bottom

Teaspoon; *c.* 1765 Maker's mark
W.L in an oval. Hanoverian stem
stamped at the end with a rose
and leaves, stamped on the bowl
with a leafed sprig carrying a rose
and a bud. 118 mm (4·6″).
Private collection

Mote spoon; *c.* 1750 No maker's
mark. Lion passant mark in use
from 1740 to 1755. The bowl
stamped with a hen and four
chicks. 134 mm (5·3″). *Christie's*

Pair of teaspoons; *c.* 1760 Maker's
mark T?.D and lion passant mark
in use after 1756. The Hanoverian
stem stamped with an eagle on a
flower garland, the back of the
bowl stamped in relief and en-
graved with a farmyard scene.
From a set of eight. 113 mm
(4·5″). *Christie's*

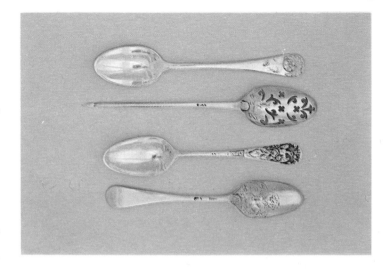

Most eighteenth-century spoons
bearing relief decoration are
simple picture or fancy-backs
(see Plates 27 and 28). Spoons with
relief decoration on their stems,
which are sometimes called fancy-
fronts, are less common. Such
stems are usually combined with
picture or fancy-back bowls, and
are most often found on tea-
spoons, early examples of the
type being shown on Plate 30.
The rose sprig design shown here
is very rare, and like the rosebud
spoon described in Plate 29 may
well be a Jacobite political type.
The design has also been found on
a dessert spoon of 1777. The hen
and chicks picture-back, as in the
case of many other designs, was
used in an almost identical form

by several silversmiths, and at least one other maker produced the
present combination of stem and bowl designs. A number of modern
casts of this type have been seen.

The term 'mote spoon', one of several possibly misleading names
which have been given to spoons with pierced bowls and long pointed
stems, was suggested in the late-nineteenth century by the idea that they
were used to remove particles or motes from the surface of tea when in
the cup. It is known that single examples were often included with sets
of teaspoons or caddies, but their precise function remains uncertain.
A late example in the Royal Collections was catalogued as 'A Chased
Spoon Tea Strainer' in 1832, and it is possible that the pierced bowl was
used in some way for straining and the stem used for clearing the large
tea leaves of the time from the teapot spout or grate. While most
examples are of teaspoon size scaled up versions were also made, some
having bowls as large as tablespoons. A teaspoon sized example with a
marrow scoop stem is also known.

One of the earliest recorded mote spoons, which dates from before
1697, has a rounded crudely pierced bowl, and a long wire stem termin-
ating in a barbed end, which is soldered to the bowl with a rat-tail.
It is marked on the bowl with a maker's mark only, and is 190 mm
(7½″) long. From the early years of the eighteenth century mote spoons
were shaped and marked as contemporary teaspoons except for their
long stems, which became shorter as the century wore on, the barbs
tending to become longer. By about 1720 the saw piercing in the bowls
had progressed from diagonal crosses to include foliate scrolls. The type
appears to die out late in the eighteenth century. Fake mote spoons
made out of other spoons which have been reshaped and pierced are
common. Examples should be checked for marks, style, and especially
for the appropriate amount of wear on the piercing.

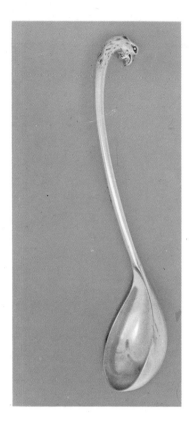

Plate 32

Ladle; *c*. 1740 Maker's mark of George Wickes, goldsmith to Frederick, Prince of Wales (1707-1751). The date letter has been rubbed off. Engraved on the front of the bowl with the Crest and Garter motto of the Prince. The stem is hollow and has been cast in two halves longitudinally and joined to the cast bowl with a lap-joint. 355 mm (14″).

Although earlier serving spoons were sometimes called ladles (see Plate 21) the earliest true ladles, with stems rising at a sharp angle to the bowl, date from the 1730s, and are of rococo type. Until the introduction of the standard type of Old English ladle about 1760 (see Plate 33) a number of different types were made, but examples are rare and perhaps always were. Among the earliest are a group of cast sauce ladles by Paul de Lamerie dating from the 1740s, the stems of which end in a down-turned scroll combined with cherubs' heads, scaling, or quilting. They are representative of a variety of rococo ladle which was the prototype of the slimmer and more elegant Onslow Pattern (see Plate 37). English eagle's head ladles, particularly early examples, are extremely rare. A ladle by Wickes hall-marked for 1743 and probably cast from the same moulds as this example is illustrated by Eric Delieb (see Bibliography), while one by Paul de Lamerie, probably marked in 1742, is at Sidney Sussex College, Cambridge, and two other examples by Wickes are associated with a tureen of the same date. Interesting late survivals are an eagle-headed pair of about 1775 by Wickes's successors Parker and Wakelin, and another pair of ladles of about 1760 by Thomas Heming, probably made for George III and in the Royal Collections. The latter have the unusual drop-shaped bowl of this example but the stems terminate in cockerels' heads. Eagle's head and scroll-end sauce ladles most often appear accompanying sauce-boats of the 1730s and 1740s.

In addition to these types there is a group of more conventional ladles bearing on their stems more or less elegant rococo scrolls cast in relief. An example by Paul de Lamerie of 1738 is known, but the type seems to have been more popular in Ireland than in England. Irish eagle's head ladles are also known. Shell bowls, a rococo form, are seen on all these types.

It is interesting to note that a number of rococo spoons and ladles are either unmarked or struck with maker's marks only. (See Plates 37, 38.)

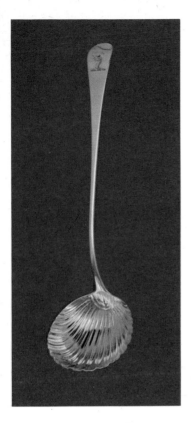

Plate 33

Soup ladle; 1764 Maker's mark of
William Wooler. Old English
stem. 340 mm (13·4″).

The Old English form, which is characterised by a stem turned down
at its rounded end, is entirely unlike the contemporary Fiddle Pattern
types in France and is probably of English origin. It occurs on a soup
ladle made as early as 1752 and it seems possible that, like the Onslow
Pattern, it was initially intended for ladles, on which the awkwardly
upturned Hanoverian stem is rarely found. By 1760, the year in which
several customers ordered 'turn'd back' flatware in the Garrard Ledgers,
Old English spoons of the type shown in Plate 34 were being made. It is
interesting to note that the shoulders characteristic of these spoons do
not always occur on Old English ladles of the period, although they
may be seen on Onslow pattern examples (see Plate 37). The fluting
and stamped double-ring drop, which are visible on both sides of the
bowl of this ladle, are typical of the 1760s.

Plate 34

Two dessert spoons; 1767 Maker's mark probably that of Thomas and William Chawner. 180 mm (7·1″). *Christie's*

Two teaspoons; *c.* 1770 Maker's mark probably that of Thomas and William Chawner. 124 mm (4·9″). *Private collection*

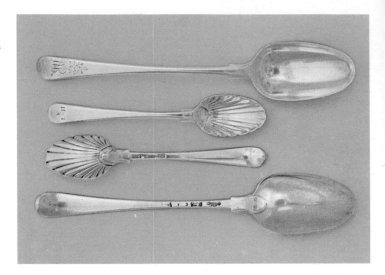

This transitional type of Old English spoon was current from the late 1750s until the first half of the 1770s. It is characterised by a rather slimmer stem than the fully developed Old English form (see Plate 35) and by two projecting shoulders at the junction of the bowl and stem. The bevelled edge, a French feature quite unlike the rounded edges of contemporary Hanoverian spoons, is frequently found on the stem. This is the earliest common use of the flat-edged stem which became characteristic of much plain late-eighteenth- and nineteenth-century flatware. The die-stamped fluted bowls of the teaspoons are characteristic of the 1760s. Spoons of this and the later Old English type, as well as Onslow Pattern examples, sometimes carry 'feather-edging', a form of decoration used chiefly between about 1760 and about 1780, which should be regarded with caution when found on pieces outside that period. Because of their short period of production shouldered Old English spoons are relatively rare.

The Chawners, who were partners from 1763 to 1774, and John Lampfert (see Plate 37), all specialist spoonmakers, produced much of the fashionable flatware made during this period. Thomas Chawner had been apprenticed to Ebenezer Coker (see Plate 28), and had as his apprentices George Smith and William Fearn (see Plate 37).

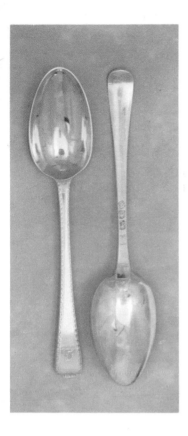

Plate 35

Two tablespoons; 1776 Maker's mark of Hester Bateman. The interiors of the bowls probably gilded in the nineteenth century. 219 mm (8·6"). From a set of three.

In shape and proportion these spoons are typical of the Old English type made from about 1770 until the end of the eighteenth century. The stems are long and narrow, rectangular in cross-section, and have behind their turned down ends an embryo ridge similar to that on the front of contemporary Hanoverian spoons (see Plate 25). The bowls are egg-shaped. The fronts of the stems are decorated with a bright-cut wrigglework border enclosing an engraved zig-zag line. By about 1780 bright-cut designs are often found to cover the whole of the stem, particularly on smaller spoons, a fashion which died out in the early-nineteenth century (see Plate 38). The elegant Old English flatware of this period was also ornamented with beaded and reeded or threaded edges, examples of which may be seen on Plate 37. Threaded edges, which had been used on French flatware from the early-eighteenth century onwards, came into vogue all over Europe at the end of that century.

Spoons of this date are still common, but these examples by a famous maker are in particularly fine condition, and are very clearly bottom-marked.

Plate 36

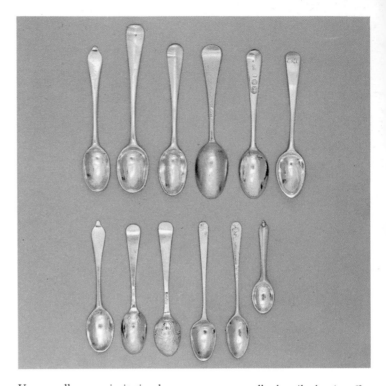

Top row, left to right

Spoon; *c.* 1700 Lion's head erased Britannia standard mark and an indecipherable maker's mark. Rat-tail bowl. 77 mm (3″).

Salt or mustard spoon (?); *c.* 1720 An indecipherable maker's mark only. Rat-tail bowl. 89 mm (3·5″).

Spoon; *c.* 1735 Lion passant and an indecipherable maker's mark. Single drop bowl. 80 mm (3·1″).

Toy spoon (?); *c.* 1745 Maker's mark only: J.C in script. 81 mm (3·2″).

Two toy (?) spoons; 1799 Maker George Smith.(Fallon No. 4). Old English stem. 78 mm (3·1″). From a boxed set of twelve with a pair of sugar tongs, given to the Victoria and Albert Museum by H.M. Queen Mary.

Bottom row, left to right

Toy spoon (?); *c.* 1695 Maker's mark only: AH crowned above a rosette. Plain bowl back. 69 mm (2·7″).

Spoon; *c.* 1750 An indecipherable maker's mark only. Stamped shell on bowl. 69 mm (2·7″).

Etui spoon (?); *c.* 1760 Maker's mark only: NH in script, perhaps for Nicholas Hearn of London. Scroll stamped on bowl. 71 mm (2·8″).

Etui spoon; *c.* 1770 Unmarked. Stem stamped with a sprig held by a bird, the rest of the design rubbed away. Back of bowl stamped with a sprig. 72 mm (2·8″).

Etui spoon; *c.* 1770 Traces of a maker's mark. The stem stamped with a garland design. Back of bowl stamped with a sprig and shell. 71 mm (2·8″).

Toy spoon; *c.* 1735 Unmarked. Cast whole. 48 mm (1·9″). From a boxed set of 18 knives, forks and spoons.

Very small spoons imitating larger types are usually described as 'snuff spoons', but the function of most of them is uncertain. A large number were no doubt made as toy or dolls' spoons, among which may be counted at least some of those in the rare boxed sets. A loose set of probable toy spoons dating from as early as 1684 is known. The spoon marked AH crowned (bottom row) is so described on the basis of a set of toy forks similarly marked. Francis Buckley (see Bibliography) suggested that these spoons were of the type described in contemporary advertisements as 'small tea spoons'. The generous proportions of the spoon of about 1745 (top row) suggest that it is also a toy. Spoons of uncertain function, but perhaps used for snuff, are found in étuis from about 1740 onwards, but unless they have the thin stems shown here, which allow their easy removal from the small étui, single specimens are often indistinguishable from toys. Early small spoons may also have been used for mustard or salt, a function which seems reasonable for the long-handled spoon of about 1720 (top row). The only certain snuff spoons, occasionally found associated with snuff boxes and about 40 mm (1½″) long, are not shown here. All these spoons are comparatively rare.

Plate 37

Left to right

Salt ladle, Onslow Pattern; *c.* 1770 Maker's mark of John Lampfert only, struck twice. Cast finial attached by a scarf joint, the bowl stamped (?) in thin silver. 122 mm (4·8″). One of a pair associated with a pair of salts by Robert Hennell of 1772.

Mustard or salt ladle; *c.* 1780 Maker's mark indecipherable. Beaded edge, Old English stem. 104 mm (4·1″).

Cream ladle (?); 1790 Maker's mark of Hester Bateman. Leopard's head mark omitted. Old English stem, rising steeply from the re-gilt bowl. 123 mm (4·8″).

Pepper ladle; 1792 Maker's mark of George Smith and William Fearn. Leopard's head mark omitted. Double threaded Old English stem and a pierced flat-bottomed bowl. 104 mm (4·1″).

Mustard spoon; 1795 Maker's mark of George Smith and William Fearn. Leopard's head mark omitted. Old English stem. 104 mm (4·1″).

Mustard ladle; 1796 Maker's mark of George Smith. Leopard's head mark omitted. Double threaded Old English stem. Associated, together with the pepper ladle above, with a cruet stand of 1796 by John Schofield. 98 mm (3·9″).

Mustard ladle, King's Pattern; 1827 Maker's mark of Charles Eley. Re-gilt bowl. Length 119 mm (4·7″). *Private collection*

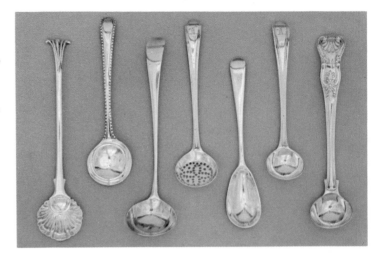

Ladles smaller than sauce ladles (Plate 44) were introduced to accompany the deep vessels, often of vase or urn form, which were used from the mid-eighteenth century onwards for sugar, mustard, cream and condiments. Sets of vase shaped containers for sugar, pepper and mustard supplied with two pierced and one unpierced ladle of rococo form date from about 1750. They were made until 1790 at least, by which date cruet frames sometimes included mustard and pepper containers with ladles of the type shown here. Separate mustard pots with ladles were, of course, also made. Open sugar containers were in use from the 1760s onwards. Their pierced ladles, known as sugar sifters, had reached sauce ladle size by the end of the century, when they formed part of the dessert service (see Plate 44).

The earliest cream containers with no pouring lip date from the 1730s, but surviving examples of their accompanying cream ladles are usually of a later date. In form they are very similar to and often indistinguishable from mustard ladles. The present example is perhaps a cream ladle, as it is between a mustard and a sauce ladle in size. More elaborate designs were also made individually and as part of dessert services. All types of small ladle made before about 1770 are rare.

Mustard spoons of the type shown here first appear, with Hanoverian stems, about 1750. The intervening type between these and the earlier condiment spoons (see Plate 18) may have been a kind of miniature spoon (see Plate 36). The bowl of this spoon is very similar to that of the earliest egg spoons (see Plate 48), but the stems of mustard spoons are generally shorter in proportion to the length of the bowl.

The Onslow Pattern, a refined and standardised version of the scroll-ended rococo ladles discussed in Plate 32, is most commonly found on ladles. Its eighteenth-century period of production was largely limited to the 1760s and its consequent rarity had led to a number of fakes being made (see Introduction). The cast scroll end is usually jointed to the stem by a soldered scarf joint. The name Onslow is probably a nineteenth-century trade term not directly connected with Arthur Onslow the mid-eighteenth-century speaker of the House of Commons, as is sometimes claimed.

Plate 38

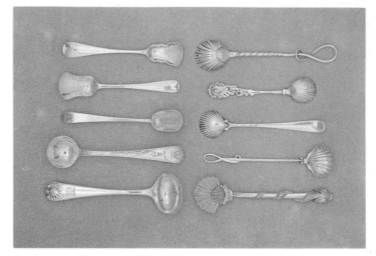

Top to bottom, left-hand column

Salt shovel; about 1750? Maker's mark J J in script. Hanoverian stem. 89 mm (3·5"). *Private collection*

Salt shovel; about 1760-70 Maker's mark T W. Hanoverian stem. 90 mm (3·5"). *Private collection*

Salt shovel; Birmingham, 1804 Maker's mark of Joseph Taylor. Old English stem. 90 mm (3·5").

Salt ladle; 1791 Maker's mark of William Sutton. Bright-cut Old English stem, the bowl gilt. 102 mm (4"). *Private collection*

Salt ladle; Plain Shell Pattern; 1827 Maker's mark of William Eley Junior. The shell is double-struck. 102 mm (4"). *Private collection*

Top to bottom, right-hand column

'Whiplash' salt spoon; perhaps 1740-50 Unmarked. 105 mm (4·1"). *Private collection*

Salt spoon; perhaps 1760-70 Unmarked. Cast stem. 80 mm (3·1"). *Private collection*

Salt spoon; c. 1775 Maker's mark of Hester Bateman. Feather-edged Old English stem. 93 mm (3·7").

'Whiplash' salt spoon; late-eighteenth century. Unmarked. Cast stem. Of very light construction. 96 mm (3·8").

Salt spoon; 1812 Maker's mark of Thomas Holland. Silver-gilt. 102 mm (4").

Late-medieval books of etiquette recommended that salt should be taken from the salt cellar either with a clean knife or with the fingers, and salt spoons were not mentioned. They were, however, known by 1643 when one is mentioned in a will. The earliest existing type appears to be the salt shovel, although certain miniature spoons may also have been intended for salt (see Plate 36). Among the earliest examples is an unmarked set of shovels of about 1730 in the Ashmolean Museum, Oxford, but dateable shovels before about 1750 are very rare. The variety with a wavy-edged bowl is perhaps the earliest type, while a date from about 1750 onwards can be given to the lighter plain-bowled type. Rococo and other stems were also used on shovels, which remained popular beyond the end of the nineteenth century.

The curled foliage stem and the related 'whiplash' stem, both products of rococo naturalism (see Plate 29) may be roughly dated from the 1730s onwards by a set of teaspoons which combine both types and which are associated with three caddies of 1735 by Paul de Lamerie. Twisted salt spoons, perhaps of the whiplash type shown here, are mentioned in the Garrard Ledgers for 1738 and round-bowled whiplash spoons, although usually unmarked, are generally dated in the 1740s. At least one very rare set of pure whiplash teaspoons is known. The shoulders on the spoon with the curled foliage stem may place it in the 1760s (see Plate 34).

Most salt ladles date from the 1770s onwards, reflecting the general development of small ladles to accompany the taller neo-classical vessels (see Plate 37). They remained the most popular type of salt spoon into the nineteenth century.

Salt spoons have, of course, adopted many novel shapes in addition to these basic types. The bowls of salt spoons are frequently gilded to stop the salt corroding the silver.

Plate 39

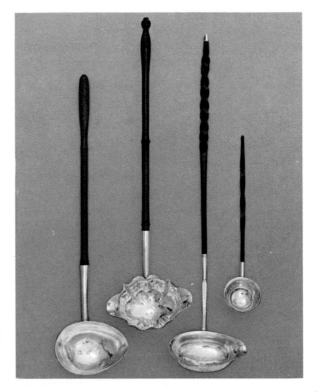

Left to right

Punch ladle; 1731 Maker's mark of William Darker. A thick and deep 'goose egg' bowl, soldered to a tubular socket, the joint strengthened with a heart-shaped plate. Turned hardwood stem. 325 mm (12·8″).

Punch ladle; 1757 Maker's mark of Jacob Marsh. A fairly thick deep bowl, double lipped and fluted. 332 mm (13·1″). *Private collection*

Punch ladle; 1795 Maker's mark of E. Morley. A thin and shallow oval bowl. The flexible silver strip attached to the twisted whalebone stem breaks into a forked section before being soldered to the bowl. 367 mm (14·5″).

Toddy ladle; *c.* 1800 Maker's mark of E. Morley. Date letter illegible. A deep bowl of very thin silver, soldered to a tubular socket, the joint strengthened with an oval plate. A silver ferrule is missing from the end of the whalebone handle. 182 mm (7·2″).

Punch drinking began in England in the seventeenth century, and it became an important social habit in the eighteenth century. There is evidence to show that so-called basting spoons were used for punch (see Plate 21), but the well known type of punch ladle with a round bowl and straight handle was already in use by about 1685, the date of an example belonging to Stamford Corporation. Turned wood or ivory handles were also used and generally replaced silver handles on punch ladles from about 1730. From about 1760 light twisted whalebone handles were used, which were usually joined to the bowl by a thin flexible silver strip. The round or oval bowl, plain or embossed and chased, was popular until the nineteenth century, and was often cleverly beaten out of a coin, the inscription being visible on the edge. Bowls were also set with gold or gilt coins, frequently of an earlier date than the ladle.

The so-called goose-egg type which began in the 1720s was one of the earliest to depart from the round type and by 1740 a number of other shapes had appeared, including an attractive type, not shown here, formed as a spiral shell. From about 1760 bowls generally became much lighter and shallower and were frequently stamped from thin sheet. Small ladles with deep round bowls were introduced at the end of the century for toddy. Punch ladles are generally marked in the bowl, but later examples are often unmarked.

53

Plate 40

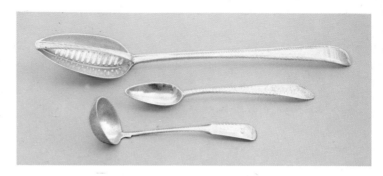

Front to back

Sauce or cream ladle; Scottish, Perth, *c.* 1800 Maker's mark of Robert Keay Senior. Fiddle Pattern stem and round bowl. 154 mm (6·1″).

Dessert spoon; Irish, Limerick, *c.* 1790 Maker's mark of Thomas Burke. Pointed Old English stem, bright cut engraved with a Prince of Wales's feathers design. 180 mm (7·1″).

Dividing or straining spoon; Irish, Dublin, 1789 Maker's mark of John Dalrymple. Double-threaded Old English stem. Removable vertical strainer grid in the bowl. 308 mm (12·1″).

A number of spoon types were unique to Scotland and Ireland, and even English forms, which in Scotland do not seem to have been used before the introduction of the trifid about 1670, frequently showed local characteristics. The rarely-found Scottish seal-top, in use from at least 1573, was a distinctive type having a thin flat stem not unlike that of the later English puritan spoon and a flattened oblong or oval seal. The bowl, as in the disc-end type below, was of rounded shape with a small rat-tail of Continental form. The disc-end spoon was the chief Scottish type from the late-sixteenth century until the introduction of the trifid. The bowl and stem were similar to that of the seal-top except that the end of the flat stem was shaped as a disc above a band of ornament and engraved. This type was copied for the celebrated York death's head spoons of the second half of the seventeenth century (see Introduction). Scottish spoons until the end of the seventeenth century frequently carried wriggle assay marks of Continental type. The Scottish Fiddle Pattern, introduced as early as the 1730s and made until the nineteenth century has been called the 'oar-end' type by one writer. It lacked shoulders near the bowl and developed a distinctively elongated broad section at the end of the stem. The English Fiddle Pattern type shown here has the same elongated tendency. The rat-tail was revived on a number of early-nineteenth-century Irish Fiddle Pattern spoons. The pointed-end Old English spoon, a type unknown in England but not on the Continent, was popular in both Scotland and Ireland from about 1780 to the early-nineteenth century, and in Ireland was often decorated with bright-cut engraving. Such Irish and Scottish spoons are often light and thin. The Prince of Wales's feathers design was peculiar to Limerick.

Serving spoons considerably larger than most of their English counterparts, being about 317 mm (12·5″) to 367 mm (16″) long, are known as hash spoons and were made in Scotland and Ireland from the early-eighteenth century onwards. The late-eighteenth-century Scottish sauce or cream ladles, often known as 'toddy ladles' have deep hemispherical bowls from which their handles rise almost at right angles. Straining spoons with pierced grids in their bowls, presumably used to remove the fat from the gravy when serving, were more popular in Scotland and Ireland than in England. Most examples, including one of 1763, have vertical grids, usually fixed, but an Irish example of about 1785 has one half covering the bowl. Serving spoons with the end of the stem bent over, probably for purposes of suspension, are usually found to be Irish.

This plate clearly shows the characteristically turned down stem of the Old English pattern (see Plates 33 to 35).

Plate 41

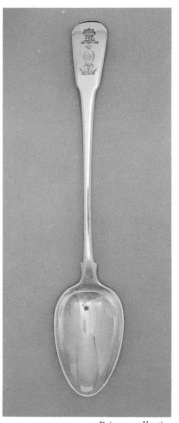

Serving spoon; 1798 Maker's mark of William Eley and William Fearn. Fiddle Pattern stem with a bevelled edge, engraved at the top with the crests of Admiral Lord Nelson. Single drop on the bowl. 302 mm (11·9″).

Private collection

The Fiddle Pattern originated in late-seventeenth-century France, and from the second quarter of the eighteenth until the nineteenth century it was the commonest French flatware type. Apart from some isolated earlier examples directly derived from French Fiddle Pattern types its popularity in England dates from the 1780s. Shortly after 1800 it superseded the Old English as the commonest nineteenth-century flatware pattern. Plain examples often have the bevelled edges shown here, but it was also very popular, particularly early in the century, when decorated with threaded edges (Fiddle Thread) (see Plate 37) or with threaded edges and a stamped shell at the end of the stem (Fiddle Thread and Shell).

The term 'Fiddle Pattern' is rather puzzling when applied to stems of the type shown here, but it should be remembered that the equivalent French term, 'Modèle Violon', also covers stems with a wavy outline such as the Hourglass type (see Plate 43) which are closer to a violin in shape.

Fiddle Pattern flatware, at one time rather unpopular among collectors, is now becoming more desirable. The engraved crests on this example would raise the price of an otherwise common type by about 300 per cent.

The families of Smith, Eley, Fearn and Chawner dominated spoon-making in the late-eighteenth and early-nineteenth century. Thomas Chawner, who had formed a partnership with William Chawner in 1763 (see Plate 34), trained George Smith and William Fearn. They and their descendants, and those of another William Chawner and of William Eley, made a high proportion of the spoons produced between the 1770s and the 1820s. In 1840 Mary Chawner took into partnership George W. Adams, who became probably the most prolific nineteenth-century flatware manufacturer (see Plate 48).

55

Plate 42

Left to right

Tablespoon; 1802 Maker's mark T.S. Old English stem. 221 mm (8·7″).

Tablespoon; 1823 Maker's mark of William Bateman the elder. Old English stem. 227 mm (8·9″).

Tablespoon; 1805 Maker's mark SH, and a crescent-shaped craftsman's mark. Old English stem. 218 mm (8·6″).

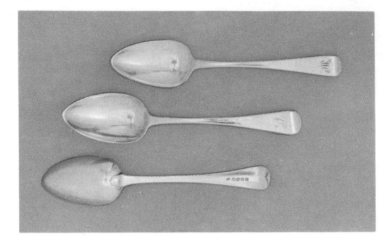

About 1800, in common with other European flatware, the bowls of Old English and Fiddle Pattern spoons become markedly wider, shallower, and more pointed. Their stems became wider at the top, and rose steeply from the bowls, so that when placed on a flat surface the bowls pointed upwards at a sharp angle. Bevelled edges which had occurred earlier (see Plate 34) were generally adopted for plain flatware. These characteristics are most marked in the spoon of 1823, and although by the middle of the century bowls had become more rounded, plain tablespoons never lost the generous proportions of this type.

The spoon of 1805 is a typical example of top-marking, with its hallmarks stamped simultaneously in a line. A small mark of the type generally believed to be a craftsman's mark, which is commonly found on flatware from the late-eighteenth century onwards, may be seen just below the separately struck maker's mark.

Plate 43

Part of a service, Hourglass Pattern; 1807 and 1808 Maker's mark of William Eley, William Fearn and William Chawner. Silver-gilt, the pattern double-struck. Front to back: egg spoon (1808), length 115 mm (4·5"); teaspoon (1807), 152 mm (6"); dessert spoon (1808), 175 mm (6·9"); tablespoon (1807), 219 mm (8·6"); gravy spoon (1808), 303 mm (11·9").

Part of a cased 182-piece service, which also includes butter, dessert and table knives, forks, sugar sifters and cream ladles, salt spoons, ice spades, grape scissors, sugar tongs, nutcrackers and gilt-mounted corks. Engraved with the crest of Walter Butler, 18th Earl and 1st Marquess of Ormonde (1770-1820).

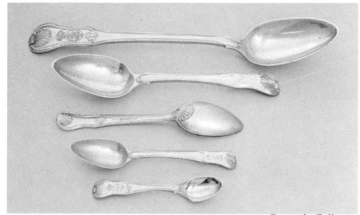

Ormonde Collection

The Hourglass Pattern, so named because of the small hourglass-like motif at the base of the stem decoration, was copied from a French rococo type which had appeared by 1760, and which itself was a standardized version of the elaborate Fiddle Pattern types current in France since the 1730s. Among the rare pre-Regency English examples are the remains of a service in the Royal Collections made during the early 1760s at the height of the pattern's popularity in France. Regency examples in that collection date from 1804 onwards, and the pattern was no doubt the peak of English fashion when this service was made. It was the earliest of the decorated Fiddle Pattern types that were to dominate flatware design throughout the nineteenth century, and was closely followed by the Honeysuckle Pattern, a variation designed for the Grand Service at Windsor and made from at least 1808 onwards; the Coburg Pattern, dating from 1812 at least (see Plate 45) and the Rosette or Queen's Pattern and King's Pattern, both of which probably date from about 1815. Of all these the King's Pattern, a slightly modified Hourglass design (see Plate 37), was to be the most popular.

Only from the late-eighteenth century does it become possible to collect a service of flatware and cutlery all by one maker and of the same date, probably because they were rarely made before that time. The present service would be completed by the addition of soup, sauce and mustard ladles. Later in the century ice cream spoons, moist sugar spoons with shovel shaped bowls, and afternoon teaspoons would also be included. The latter, which were of eighteenth century size, were probably introduced as a more elegant alternative to very large teaspoons of the type shown here (see also Plate 52) which were made from about 1800, possibly in imitation of French coffee spoons.

These spoons are double-struck, that is the design is reproduced on both sides of the stem. Single-struck spoons carry the design on the upper side only. Regency plate, like these spoons, was frequently gilt all over.

57

Plate 44

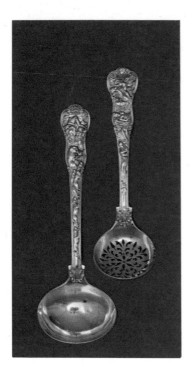

Left to right

Sauce ladle; Stag Hunt Pattern; 1816 Maker's mark of Paul Storr. Four hounds run up the stem towards the stag which twists to face them. To its right a huntsman emerges from a wood holding a hound in leash while another hound leaps forward behind him. A dead hound lies beneath them. Stamped in relief on a plain ground. The back of the stem is stamped with a trophy of arms, the drop with a Diana mask (see Plate 27) 183 mm (7·2″).

Sugar sifter, Bacchanalian Pattern; *c.* 1855 Maker probably George W. Adams, the marks removed by piercing. A sleeping bacchante occupies the lower end of the stem, while at the upper end a reclining bacchante feeds grapes to a panther which turns to look at a youth seated on its back. Stamped in relief on a stippled ground. The back of the stem is stamped with a Bacchic trophy. The drop, although not on this example, usually bears a Bacchic mask. 162 mm (6·4″).

Both designed by Thomas Stothard, RA (1755-1834) for Rundell, Bridge and Rundell, the Royal Goldsmiths.

Spoons can only rarely be assigned to a particular designer. The attribution of these patterns to Stothard, a painter and draughtsman who also designed silver, is based on a rather confused passage in his biography: 'He made another masterly set of drawings for the house of Messrs. Rundell and Bridge, of Bacchanals. These were intended for the handles of knives and forks. Amongst them may more especially be noticed the Boar Hunt silver-handled knives, and in a similar bold style of art, the Stag Hunt was designed by him for plate. I have been informed that all these . . . were frequently introduced in the ornamental place of the Duke of Devonshire, and of our chief nobility.' (Anna Eliza Bray. *Life of Thomas Stothard,* RA. London, 1851, p. 162).

A footnote states that the Boar Hunt knives were modelled by the sculptor Sir Francis Chantrey, RA. The design and modelling of the Boar Hunt are very similar to those of the Stag Hunt, and suggest that the original for the latter was also modelled by Chantrey.

The earliest versions of these patterns were made by Paul Storr, who worked for Rundell and Bridge until 1819, as part of the Grand Service at Windsor Castle which had been ordered by the Prince of Wales, later the Prince Regent. Examples of the Stag Hunt date from 1813, of the Boar Hunt from 1811, and of the Bacchanalian from 1812, the latter pattern being limited to the Dessert Service. Storr was still using the original dies as late as the 1830s, and from the mid-nineteenth century onwards examples of the Stag Hunt and Bacchanalian Patterns made by Storr's successors Hunt and Roskell (see Plate 47) and G. W. Adams are recorded. These differ from the Storr versions in their details, coarser modelling and stippled ground. Examples of all these patterns are rare, although some Bacchanalian flatware is still being made.

The Boar Hunt and Mask and Stag Hunt and Mask Patterns incorporate masks at the top of the stem at the back.

Plate 45

Soup ladle, Coburg Pattern; 1819
Maker's mark of Paul Storr.
Craftsman's mark a diamond.
Double-struck. The bowl and
stem made separately and soldered
together. Length 337 mm (13·3″).

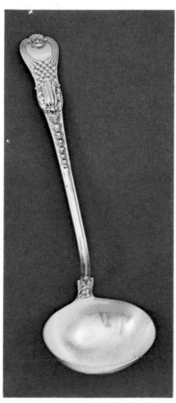

S. J. Shrubsole Ltd.

The Coburg Pattern, unlike the Hourglass Pattern (see Plate 43) was a product of the Regency, and has that quality of 'massiveness' which H. C. Tatham had stated was 'the chief characteristic of good plate' *(Designs for Ornamental Plate, 1806)*. Like other Regency designs it imposes Roman architectural forms on a rococo framework. The earliest examples in the Royal Collections, in which this pattern forms the bulk of the flatware of the Crown Service, date from 1812. All the early royal examples are by Paul Storr, as indeed are most early-nineteenth-century spoons of this relatively rare type. The large and heavy ladle shown here has the oval bowl which is characteristic of early-nineteenth-century ladles (see also Plates 38 and 44), although it occasionally occurs in earlier examples.

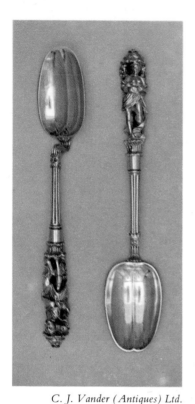

Plate 46

Two serving spoons; 1825
Maker's mark of William Eley
(Fallon No. 2). Silver-gilt. The
ribbed stem is encircled by a
grotesque mask at the lower end
and takes a sharp double curve
near the bowl, which is ridged
down the centre. The top of the
stem is cast in the form of a
female figure standing before two
twisted flowering stems terminat-
ing in an inverted flower finial.
From a set completed by two
carving knives and a fork, one of
the knives surmounted by a king
in classical dress, the other pieces
by female figures. 220 mm (8·7").

C. J. Vander (Antiques) Ltd.

Although copies of out-of-date designs had occasionally been produced
in earlier periods to complete existing services and sets (see Intro-
duction), it can be said that a new interest in the styles of the past, and
their imitation, was characteristic of Regency silver and that this
historicist approach, of which these spoons are early examples, eventu-
ally came to dominate nineteenth-century decorative art. An ability to
imitate old forms accurately is shown in the copies of the Coronation
Spoon made in 1820 by Eley and Fearn and now in the Royal Collec-
tions, and in the spoon made in 1825 to complete a mixed set of lion
sejants of 1558 to 1611. More fanciful interpretations of ancient spoons
appear in A. W. N. Pugin's *Designs for Gold and Silversmiths* of 1830 to
1836, but it is interesting to note that these designs were themselves
assumed to be ancient H. O. Westman in *The Spoon* published in 1845.
The bowls and lower stems of the spoons shown here may have been
based on those of the Coronation Spoon in Regalia which had last been
used at the Coronation of George IV in 1820. The figure ends, however,
have been closely copied or perhaps even cast from a type of box wood
handle found on some Continental seventeenth-century spoons and
cutlery, examples of which can be seen in the Pinto Collection at the
Birmingham City Art Gallery.

Most historicist spoons date from the second half of the nineteenth
century (see Plates 53 and 58).

Plate 47

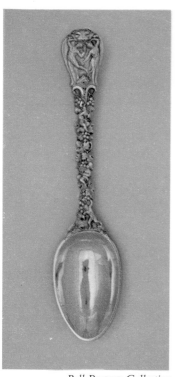

Dessert spoon; 1839 Maker's mark of J. S. Hunt of Mortimer and Hunt. Silver-gilt. The stem and back of the bowl cast and chased with vines and playing putti. The stem terminates in a bacchante and faun in relief beneath a lion's mask. On the back of the stem Queen Victoria's monogram, and the initials AVP in monogram on the bowl, cast and applied. From a boxed set of knife and fork spoon, the cast parts being by Hunt, the knife blade by Theobalds and Atkinson. 178 mm (7").

Bell Pearson Collection

'Sets of silver knife, fork and spoon. In leather cases, lined with velvet, forming tasteful christening gifts', as the Goldsmiths Alliance catalogue described them in 1870, included some of the best nineteenth-century flatware designs. They were invariably of dessert size and could also be bought with napkin rings, cups, and mugs in various combinations. Sets given by Queen Victoria to her godchildren, such as this one given to the unidentified AVP, are very desirable. Another royal set, monogrammed VLG, was made from the same moulds in 1838 by Storr and Mortimer. Paul Storr, who had gone into partnership with Mortimer in about 1822, retired in 1839, leaving the firm to Hunt, his nephew, who, after Mortimer's retirement in about 1844, was joined by Robert Roskell, forming the important firm of Hunt and Roskell (see Plates 50 and 52).

The present spoon is of unusually high quality for a design of Regency type made in the late 1830s.

Plate 48

Three egg spoons, Albert Pattern; 1848 Maker's mark of George W. Adams. Part of a larger service. 117 mm (4·6″).

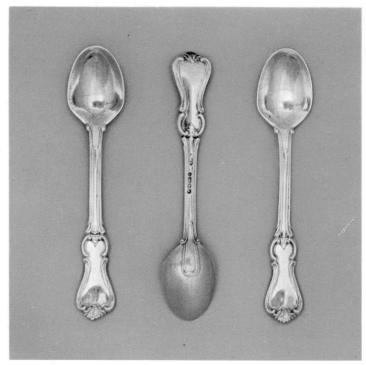

Sotheby's Belgravia

The Albert Pattern was one of the many variations designed from the 1820s onwards on the decorated Fiddle Pattern theme, which had been set by such Regency types as the Hourglass and King's Patterns (see Plates 37 and 43). It is a comparatively restrained example designed in the 1830s, and is typically early Victorian in feeling. The Victoria Pattern was a more elaborate variation. Such designs were made until the end of the century.

Egg spoons with pear-shaped bowls similar to that on the mustard spoon shown on Plate 37, but with longer handles, are known from the last quarter of the eighteenth century. The type shown here, a slightly later development, was common in the nineteenth century. Egg spoons were frequently made to be fitted into egg-stands. Their bowls were gilded to prevent the egg staining the silver.

George W. Adams, spoonmaker, who first registered his mark, together with Mary Chawner, in 1840, and Francis Higgins (later Francis Higgins and Son) who registered his mark as a spoonmaker in 1835, were together responsible for a large proportion of the flatware made during the rest of the century. Higgins in particular produced a number of striking and original spoons which are nearly always found to be of high quality, and he exhibited in several international exhibitions (see Plates 49, 52, and 53).

Plate 49

Two teaspoons; 1859 Maker's mark of Francis Higgins. The stem formed as a twig around which a convolvulus winds, finishing in the bowl with two flowers. Probably cast whole. 119 mm (4·5″). This design was shown at the Great Exhibition of 1851 (*Art Journal Illustrated Catalogue*, p. 26). *Sotheby's Belgravia*

Salt spoon; 1835 Maker's mark of William Bateman Junior. Convolvulus stem, separately cast, terminating in a gilt flower-shaped bowl. 96 mm (3·8″). Designed *en suite* with a salt cellar of 1832 by the same maker, formed as a large convolvulus flower.

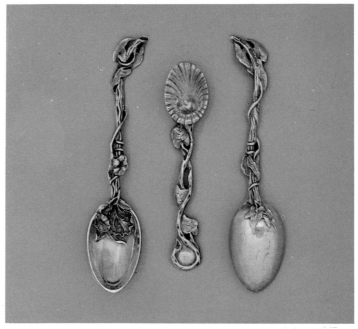

Sotheby's Belgravia

The nineteenth century naturalistic style, which first became popular in the 1830s, was largely inspired by the rococo naturalism of the previous century (see Plate 29). Unlike the earlier style, however, it often used whole plants and flowers, with very little adaptation, as models for vessels or flatware. The convolvulus was particularly popular, as a writer in the *Art Journal* of 1849 remarked: 'where else have we the same graceful, clinging, affectionate tendril? The spiral bud, the drooping leaf hiding half the beauties of the stem and flower,—the same flower different in every position it assumes, but beautiful in all . . . what purpose is there in Decorative Art to which its beauties may not be transplanted?'

In flatware this naturalistic treatment was largely limited to dessert services, ladles, and novel types such as caddy spoons. At the 1851 Great Exhibition Francis Higgins showed a cream ladle based on a buttercup plant with gilt flowers, and two caddy spoons, one shaped as a mussel shell, the other as a wild anemone 'copied with as much fidelity as its application to the form of a caddy spoon would permit'. At the Dublin Exhibition two years later he showed a teaspoon similar to those illustrated here but based on the rose. Naturalism had ceased to be a dominant style by 1860, but it continued in use beyond the end of the century when a number of pieces influenced by Japanese naturalism were made, dating from the late 1860s onwards.

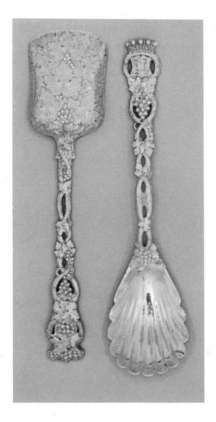

Plate 50

Left to right

Ice spade, Vine Pattern (back); *c.* 1850 Stamped HUNT & ROSKELL. Silver-gilt. The interior of the bowl smooth, and the front of the stem carrying a blank cartouche. 241 mm (9·5″).

Dessert serving spoon, Vine Pattern (front); *c.* 1850 Maker's mark of George W. Adams. Silver-gilt with an undecorated bowl. Cast at the top with a Russian coat of arms and on the back with a monogram. 239 mm (9·4″).

Dessert services not based on the common spoon types are extremely rare before about 1770. One such set by Frederick Kandler is already cast and chased with shells, grapes and vine tendrils, in anticipation of similar nineteenth-century sets. The extensive use of the Vine Pattern (sometimes called Pierced Vine, as here, or Bright Vine when unpierced) began in the first decade of the nineteenth century and was generally confined to dessert sets, teaspoons, and other small spoons. These rather ostentatious serving spoons show how the vine tendrils became less formalized and symmetrical under the influence of naturalism (see Plate 49). Particularly interesting is the manner in which the tendrils at the end of the ice spade stem have been shaped as a crown, lending an air of dignity to the initials or crest which would have been added to the blank cartouche beneath. The most showy, and some of the most original, nineteenth-century flatware designs were used on dessert services, which were frequently gilt to prevent staining.

Ice spades used for serving and eating ices probably originated in the late-eighteenth century. 'Ice Spoons' appear in the Garrard Ledgers for 1768 and a French ice spade of about 1770 is recorded. Both these servers were made for and used as patterns by the firm of Hunt and Roskell, and the ice spade has consequently not been hall-marked. (See also Plate 52.)

Plate 51

Ladle; 1853 Maker's mark of
Robert Garrard, for R. and S.
Garrard. Marked on the back of
the bowl. 305 mm (12").

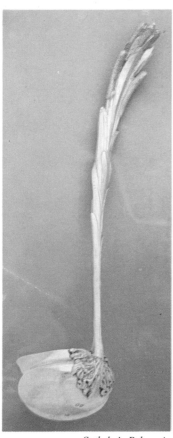

Sotheby's Belgravia

This unusual and heavy ladle, by Garrards the Crown Jewellers and
Goldsmiths, is a particularly fine example of the naturalistic style. The
stem is cast and chased in the shape of a bulrush, the root of which is
soldered to a separately made bowl having a pouring lip on one side.
The bulrush motif, a popular one in mid-nineteenth-century decorative
art, was also used during the rococo period in France.

Plate 52

Teaspoon, Lily Pattern (front); after 1850 Maker's mark of George W. Adams. Stamped on the drop with the registered design mark for 21 January 1850, registered by Elkington Mason and Co. of Birmingham. Also stamped PATTERN. Double-struck stem. 150 mm (5.9").

Teaspoon, Tudor Pattern (front); after 1850 Maker's mark of John S. Hunt for Hunt and Roskell. Stamped on the stem with the registered design mark for 14th August 1850, registered by George W. Adams under his trading name of Chawner and Co., London. Also stamped PATTERN. Double-struck stem. 148 mm (5.8").

Teaspoon, 'Ornamental Elizabethan Pattern' (back); 1853 Maker's mark of Francis Higgins. Fully hall-marked. Stamped on the bowl with the registered design mark for 21 December 1852, registered by Francis Higgins. Also stamped HUNT & ROSKELL. Double-struck stem. 147 mm (5.8"). This design was shown at the Dublin Exhibition of 1853.

Teaspoon (back); 1872 Maker's mark of Hunt and Roskell. The front of the stem stamped with a blank cartouche surmounting a ram's head and garland. The backs of the tablespoons and forks in the same service carry designs of hanging game and fish respectively. 148 mm (5.8").

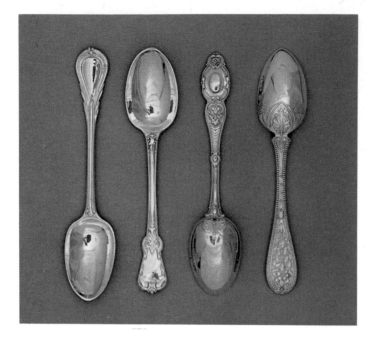

These teaspoons, like the servers on Plate 50, were used by the firm of Hunt and Roskell as patterns for their flatware, and are in consequence in mint condition. The three earlier spoons belong to a group of the nineteenth-century designs which used various types of fashionable ornament yet did not entirely depart from the decorated Fiddle Pattern format. The Lily Pattern is, of course, of naturalistic origin. The Tudor and 'Ornamental Elizabethan Pattern', as it is described in the design register, are in the so-called 'Tudor' style, which was chiefly based on Jacobean strapwork motifs. The bowl of the Higgins spoon is ridged down the centre, a feature which occurs in other Higgins pieces and was perhaps inspired by the bowls of Continental Renaissance spoons.

The last spoon is derived from French flatware of the Empire period, although it also contains other stylistic elements. Similar designs were being made in France in the 1860s as part of a conscious Empire revival. It reflects that new interest in eighteenth-century styles which gained momentum in the 1860s and which by the end of the century had produced designs derived or copied from most eighteenth and several seventeenth-century flatware types.

Plate 53

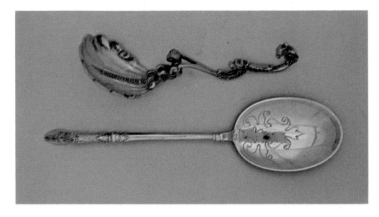

The dessert spoon shown here is probably a copy of a Dutch spoon of the mid-seventeenth century. The serving spoon is, perhaps, based on a German or Italian sixteenth-century original; a letter associated with the set implies that it was copied from a 'cabinet antique spoon' although the antiquity of this original should perhaps be regarded with caution (see Plate 46). This historicist approach to design, which began in the Regency period (see Plate 46), had become widespread by the second half of the nineteenth century. By the end of the century several Continental and most English types had been copied, including the Hanoverian (as opposed to the 'plain' or Old English which had never stopped being made), the wavy-end and the trifid, which was rather puzzlingly and typically called 'James I'. The majority of spoons based on Continental types are of Continental origin (see Plate 58). The more extreme forms were of necessity restricted to dessert flatware. Among the most striking examples is a set of spoons from a dessert service designed by William Burges and made for the Marquess of Bute in 1880, and now in the Victoria and Albert Museum. These are based on Roman metal spoons except that the stems are formed as clustered Gothic columns, the bosses half way up and capital finials being set with semi-precious stones.

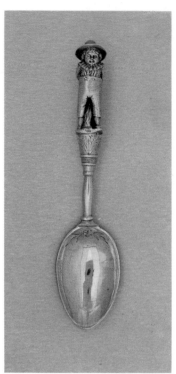

Bell Pearson Collection

Plate 54

Dessert spoon; 1882 Maker's mark of Sampson Mordan. Parcel-gilt and bright-cut engraved. The stem surmounted by a cast figure derived from a drawing on the cover of Kate Greenaway's *Under the Window* first published in 1879. A rat-tail on the back of the bowl. Part of a christening set, the knife and fork surmounted by figures of a boy coachman and a girl in a bonnet, both in the style of Kate Greenaway. The accompanying mug is decorated with cast and applied figures based on pages 44 and 45 of *Under the Window*. 167 mm (6·6″).

Spoons with large figure finials in silver are an unusual nineteenth-century type. Among the earliest examples is a set of 1816 having putti finials and leaf-shaped bowls. Such finials were probably derived from the handles of seventeenth-century flatware and cutlery. Francis Higgins made dessert sets of the same type but surmounted with other Bacchanalian figures, recorded examples of which date from 1859. The present spoon reflects the enormous popularity of the children's books of Kate Greenaway after the publication of *Under the Window*; a volume of inked impressions taken from silver and plate by several makers engraved with Greenaway subjects, many of them from *Under the Window*, is in the Victoria and Albert Museum. Such subjects were, of course, especially suitable for christening sets but they have also been found on scent bottles and other small objects made by Mordan, a manufacturer best known for his propelling pencils (Telegraphic address: 'Pencils London').

Plate 55

Soup ladle; from 1880 Electro-plated base metal and ebony (examples also exist with ivory handles). Made by Hukin and Heath of London and Birmingham, and stamped with the registered design mark for 28th July 1880. *En suite* with an ebony-handled electro-plated tureen stamped 'Designed by Dr C Dresser', 'H&H', '2123' and with a registered design mark as above. 750 mm (13·6″).

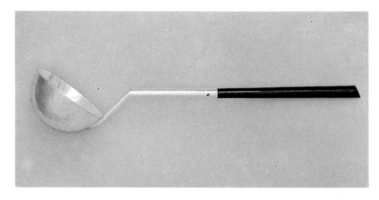

This ladle, although only plated with silver, has been included as an example of the astonishingly simple and functional metalwork designed from the 1870s onwards by Dr Christopher Dresser (1834-1904). Dresser, a botanist and free-lance designer, avoided historical precedent as far as possible for his forms by designing from basic principles, and in his metalwork largely dispensed with surface ornament as it was intended for machine production. The bowl of this ladle has probably been formed by spinning on a lathe. The difficult change of angle in the tubular stem has been simply and effectively achieved by flattening the front of the lower portion, to which the bowl can easily be soldered. The ebony handle, an example of what has been described as Dresser's 'intelligent and imaginative eclecticism', derives from his interest in Japanese artefacts. This interest, which was widespread in the 1870s and 1880s, was usually expressed in flatware by stamping or engraving the stems with asymmetrical designs of Japanese bird and foliage and symbols, and in a revival of naturalistic spoons (see Plate 49), but in the Japanese taste.

Plate 56

Preserve spoon; Birmingham, 1901 Maker's mark of Liberty & Company (Cymric) Ltd. Probably designed by Archibald Knox (1864-1933), and made by W. H. Haseler Ltd. of Birmingham. Cast silver inlaid with enamel. Inscribed 'AC ER VII' in commemoration of the Coronation of Edward VII. 125 mm (4·9″).

Two tea or coffee spoons; 1901 Maker's mark of the Guild of Handicraft Ltd. Designed by C. R. Ashbee (1863-1942). Set with stained chalcedony in imitation of chrysophrase. 86 mm (3·4″).

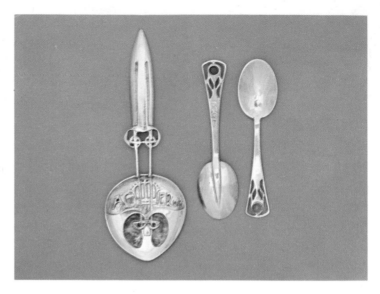

A radical break with old forms took place in the late-nineteenth and early-twentieth centuries with the development of Art Nouveau on the Continent and the Arts and Crafts movement in England—a break which affected the design of some spoons. The most usual feature of such spoons is a stem which develops into a more or less stylised Art Nouveau plant form, while the bowl frequently retains the old shape. Spoons with fig-shaped bowls and slim stems, sometimes combined with figure finials, also enjoyed a revival during this period, and there was a considerable use of enamel and semi-precious stones. The preserve spoon shown here, however, departs completely from previous types, as did much of the 'Cymric' range of silverware produced for Liberty's. Interlaced Celtic ornament, on which this spoon is based, was characteristic of Archibald Knox's designs, but it is also found on the Continent where somewhat similar spoons were produced. Two larger Coronation spoons of different design and 159 mm (6·25″) long were also made, and all three types, but without inscriptions, are advertised in a Liberty Catalogue perhaps dating from 1904, in which the present example is priced at 17/6d. While the 'Cymric' range was made largely by machine and mass-produced, the Guild of Handicraft, founded in 1888 by the architect C. R. Ashbee, worked on the Arts and Crafts principle of hand production. The slightly irregular piercing of the stems and hammer marks on the bowls of these spoons are intended to express this hand-made quality. In general form, as in a number of Arts and Crafts pieces, they are loosely based on an older original, in this case a seventeenth-century teaspoon, although the piercing and semi-precious stones are typical of Ashbee's designs.

Plate 57

Three cast slip-tops. All three have been cast from an untraced original of 1627, maker's mark T B over a mullet. The pair on the right were made before 1898, the other example before the 1920s. 154 mm (6·1″).

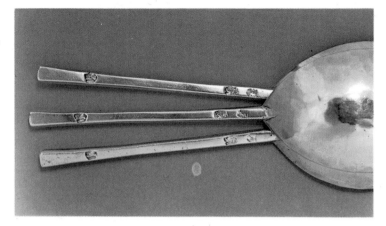

These spoons, which for ease of comparison have been arranged with their bowls together, show several features associated with cast spoons. First, the marks are all in *precisely* the same place. This should be carefully checked as genuine marks on sets of spoons, even before the introduction of group struck marks at the end of the eighteenth century, were frequently struck with only slight variations in placing. It is, of course, impossible to check this with single spoons. Secondly, the marks are shallow, poorly defined and pitted. Even good cast marks are often found to be pitted in the background. Thirdly, the stems show many tiny pit marks, a result of the manufacturing process nearly always found on cast spoons. The bowls of these spoons have been rather obviously rehammered to avoid the thick bowl characteristic of cast work and the incorrect weight such bowls give. They frequently have a 'dead' and greasy feel and lack the slight springiness of forged metal. Fourthly, the general wear is uneven, the sharply defined stem facets contrasting with poorly defined marks. Wear should above all be logical, and certain areas, particularly the right underside of the bowl, should show greater use. Knopped spoons cast whole would, in addition, lack a soldered joint between the knop and stem. Castings are not limited to early types, condiment spoons, picture-back teaspoons and other rare small spoons having been seen. It should be noted that the pit marks resulting from prolonged burial and corrosion (see Plate 10) can be indistinguishable from those produced by casting and that if such a spoon were to be 'improved' and over-burnished it would have several of the features described above.

Plate 58

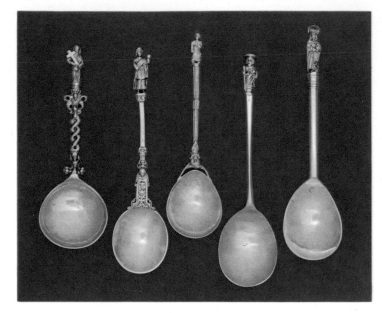

Left to right

Spoon knopped with a figure of Faith: probably Dutch, 19th century. Marked on the bowl with three towers in a square shield; probably spurious. Parcel-gilt. 171 mm (6·7″).

Apostle spoon, St John; German, 19th century. Marked on the bowl with the pineapple mark of Augsburg; probably spurious. 190 mm (7·5″). *Sotheby's*

Apostle spoon; German, 19th century. Marked on the bowl 13, a crown, G, s; all except the 13 probably spurious. The bowl held by the two arms of a figure which is visible at the back of the stem. 174 mm (6·9″).

Apostle spoon; 1778 Maker's mark of Hester Bateman. A tablespoon altered before 1898 to make an apostle spoon by re-shaping, adding a modern figure, and gilding. 195 mm (7·7″).

Apostle spoon, St Jude; 19th century. The bowl and marks have been cast from a master spoon in the Chichester Collection. Commander How discusses a complete cast taken from the Chichester spoon (*English and Scottish Silver Spoons,* Vol. 2, pp. 278-81). The width of the stem at the base has been continued up to accommodate an apostle cast from an original very similar to the St Jude in a set of 16th-century apostles in the Victoria and Albert Museum. Made before 1898. 197 mm (7·8″).

The spoon on the far left, with its typically twisted stem, is characteristic of a type of elaborate spoon which has been popular in Holland from the seventeenth century to the present day. It can be seen carrying many types of knop. During the second half of the nineteenth century a number were made bearing marks of deceptive age and nationality, and a great many were exported. In England they were often stamped with import hall-marks, usually dating from about 1900. The type was copied by English silversmiths (Francis Higgins exhibited one in 1851), but like the other Continental types shown here it was not made in England before the nineteenth century.

The German spoons are representative of a large group made in the same historicist spirit as those on Plate 53. Octavius Morgan drew attention to such spoons in 1860, and considered that they were made in Frankfurt and Vienna. They are usually more or less loosely based on sixteenth-century or seventeenth-century originals and frequently bear spurious marks. The unnamed apostle finial is typical of many Continental examples in its small size in relation to the stem. Crude conversions of the type shown by the Hester Bateman spoon, which has of course retained its hall-marks, are probably not carried out today, but more skilful examples of the practice may be seen. New and complete gilding as used on this spoon is often intended to cover signs of reworking. The cast spoon, with its great weight, thick stem, untypical apostle, and greasy feel, is easily detectable.

Plate 59

St Andrew (front and back) and St Peter. Modern finials which have been soldered to old spoons, the former perhaps to an altered seal-top. Gilt.

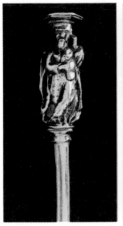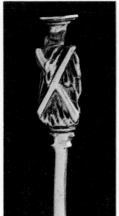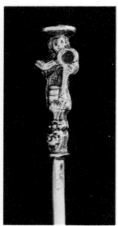

Private collection

Apostle spoons, the most extensively faked type of early spoon, are most often made by adding a modern, or occasionally genuine, finial to another spoon. The majority of such spoons are reshaped eighteenth-century tablespoons and are easily detectable (see Plate 58), but spoons of the correct date have also been furnished with apostle finials. The relatively common seal-top with its finial removed or filed down, is most frequently used, and the curious hexagonal nimbus of the St Andrew figure may have terminated an original seal-top finial. The best general indication of such a conversion is a badly balanced spoon, perhaps of incorrect shape, with a poorly fitted figure which is too large or small for the stem. It should be remembered, however, that very late seventeenth-century apostle and seal-top spoons frequently have ill-fitting and unbalanced finials. The joint used to attach the finial is also a useful guide, the St Andrew in this case being attached with a straight joint, although the original 'V' or lap joints are frequently re-used. Fake finials vary greatly in quality, good casts being considerably more convincing than the present examples.

The St Andrew has been cast, probably during the last century, from one of a well known group of Continental boxwood models illustrated by Sir Charles Jackson (I.H.E.P., Vol. II, p. 507). Identical and similar castings, which in their distinctive drapery and small size are quite unlike English finials, have been found in some numbers. The group also includes the Evangelists with their symbols at their feet. The crude St Peter finial has been derived from an English original but seems to have been cast whole with, perhaps, the mutilated remains of a seal-top.

Apart from new casts there are spoons with genuine finials which have had their modelling re-tooled and their emblems or nimbi re-placed. Complete gilding as shown on these spoons has often been used to cover reworking, and should in any case arouse suspicion, as in the past nearly all knopped spoons appear to have had only their knops gilded. Conversely, a finial showing no trace of gilding is highly suspect.

Plate 60

Above

Sugar spoon; 1600 Maker's mark
a dove holding an olive branch.
A seal-top spoon which has been
embossed, chased, engraved,
pierced in the bowl and parcel
gilded in the mid-19th century.
160 mm (6·3″).

Below

Berry spoon; 1798 Maker's mark
R G. A plain spoon which has been
embossed, chased, engraved and
parcel gilded in the late-nineteenth
century. 223 mm (8·8″). From a
boxed pair.

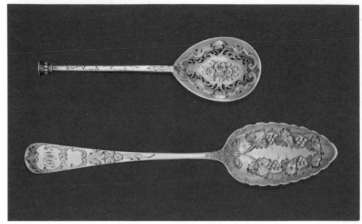

Sotheby's

From the 1820s onwards plain old plate was frequently chased and
embossed, generally in a rococo manner, in order to convert it to the
elaborate taste of the time. In hollow-ware this practice was largely
limited to the late-Georgian and early-Victorian period, but the
embossing of spoons, to create so-called 'berry' or fruit spoons,
continued and is unfortunately still carried on today. Plain late-
eighteenth-century spoons are generally used, and pairs or sets are
created by embossing and engraving odd spoons with the same design.
Such designs were not used on eighteenth-century spoon bowls, which
rarely received other than simple fluting. Seal-top spoons are now, of
course, too valuable to suffer the conversion shown here.

SELECT BIBLIOGRAPHY

Silver spoons

BUCKLEY, F. 'Small Silver Spoons', 'Emblematic Tea Spoons in the Eighteenth Century', *The Antique Collector,* Sept., Dec., 1931, 457 *et seq.,* 794 *et seq.*

BUCKLEY, F. *Seventeenth-Century Tea Spoons,* privately printed, 1928.

CLAYTON, M. *The Collector's Dictionary of the Silver and Gold of Great Britain and North America,* Country Life, 1971.

DELIEB, E. *Investing in Silver,* Barrie and Rockliff, 1967.

GASK, N. *Old Silver Spoons of England,* 1926. Facsimile reprint, Hamlyn, 1973. In need of revision.

HARRIS, I. *The Price Guide to Antique Silver,* The Antique Collectors' Club. 1969-70. The price list is regularly revised.

HOW, G. E. P. AND J. P. *English and Scottish Silver Spoons,* 3 Vols., privately printed, 1952. The standard work on spoons before 1700, with an important section on early hall-marks.

HOW, G. E. P. 'The Cult of the teaspoon', *Notes on Antique Silver,* No 4, pp. 32-39, privately printed, 1944-45.

HOW, G. E. P. 'Electro-plating Antique Silver, should it be permissible?', *Connoisseur,* CXXIV, Dec. 1949, 112-3, 140.

HUGHES, G. B. 'Silver punch-ladles', *Country Life,* Nov. 1950, p. 1690.

JACKSON, C. J. 'The Spoon and its History', *Archaeologia,* LII, Part I, 1890, 107-46. Monograph 1892. The basis of most later studies.

JACKSON, C. J. *An illustrated history of English plate, ecclesiastical and secular,* 2 Vols., 1911; reprinted 1967, Holland Press.

KAUFFMAN, H. J. *The Colonial Silversmith,* Thomas Nelson, 1968. On spoon manufacture.

THE LONDON MUSEUM. *Medieval Catalogue,* 1940.

ORMSBEE, T. H. 'The Craft of the Spoonmaker', *Antiques,* XVI, 3, pp. 189-92.

PICKFORD, I. 'Early English Silver Spoons', *The Antique Finder,* 11, No. 12, 10-13.

RUPERT, C. G. *Apostle Spoons: their evolution from earlier types, and the emblems used by Silversmiths,* Oxford, 1929. Many of Rupert's ideas are contested by How.

WHITE, J. S. 'Scottish Silver Tablespoons', *Scottish Art Review,* XI, No. 2, pp. 12 *et seq.*

Base metal spoons

BENNET-CLARK, H. 'The Importance of Taste in Plate, Sheffield Plate Flatware', *Country Life,* Feb. 1973, 388-9.

BRADBURY, F. *A History of Old Sheffield Plate,* London, 1912.

Bradbury includes a section on modern spoon manufacture.

HILTON PRICE, F. G. *Old Base Metal Spoons with Illustrations and Marks*, B. T. Batsford, 1908.

HOMER, R. F. 'Unique Medieval pewter spoon', *Connoisseur*, CLXXX, April 1973, 263-4.

MICHAELIS, R. F. 'Royal Portrait Spoons in Pewter', *Apollo*, LI, June 1950, 172-3.

PEEL, C. A. 'English Knopped Latten Spoons', *The Connoisseur*, CLXXXIII, 254-7, 174, 196-200.

Hall-marks; general

BRADBURY, F. A. 'Marking Anomalies of Silver Plate in the 18th century', *Connoisseur*, XCII, 1933, 295-7. On overstruck marks.

CASTRO, J. P. *The Law and practice of marking gold and silver wares*, 1926 (2nd ed., 1935).

JACKSON, C. J. *English goldsmiths and their marks*, 1905. 2nd ed., 1921, reprinted 1949. Facsimile reprint 1964 by Dover Publications. The standard work on the marks of the British Isles.

Hall-marks; London

COX, H. C. 'Goldsmiths' marks misread', *Connoisseur*, CL, June 1962, 188.

FALLON, J. P. *The Marks of the London Goldsmiths and Silversmiths, Georgian Period (c. 1697-1837): a Guide*, David and Charles, 1972. A selection of makers' marks copied directly from the records of the Goldsmiths' Company. 'The Mistaken Identification of Some Familiar Silversmiths and their Marks', *Antique Dealer and Collectors' Guide*, October, 1973, 104-8.

HOUSE OF COMMONS. *Report from the Committee appointed to enquire into the manner of conducting the several Assay Offices, Appendix I*, 1773. A list of London goldsmiths specifying spoonmakers during the period of the lost mark ledgers.

HOW, G. E. P. 'Date letters on London Silver prior to 1478; the 'Lombardic' date letter 'E' for 1466?', *Connoisseur*, CXXIII, June 1949, 106-7.

Provincial hall-marks; general

The present scattered literature on provincial marks leaves many areas unexplored. Jackson and Commander How's Ellis Collection Catalogue remain the best general introduction.

ELLIS, H. D. Observations on provincial hall-marks, *Proc. Soc. Antiqs. of London*, XXIII, 37-46.

HOW, G. E. P. *Catalogue of the entire Collection left by the late H. D. Ellis, Esq., . . . the property of Lieut.-Col. J. Benett-Stamford.* Sotheby sale, 13-14 November, 1935, and 15, 16 April, 1937. The most complete single account so far of provincial spoons and their marks.

JONES, E. A. 'Some English Provincial Goldsmiths', *Apollo*, XXXIX, 49-51.

OMAN, C. C. *English Church Plate, 597-1830*, Oxford, 1957.
Oman also discusses ecclesiastical spoons.

Provincial hall-marks;
local centres
Bristol

MORTON, H. E. AND HUDLESTON, C. R. 'Bristol Gold and Silver-smiths and Clock and Watchmakers', *Bristol and Gloucester Arch. Soc. Trans.*, LX, 1938, 198.

Carlisle

FERGUSON, R. S. 'On a supposed touch or assay of silver at Carlisle', *Cumberland and Westmorland Arch. Soc. Trans.*, VII, 1883, 64-68.
HOPE, L. E. 'A Seventeenth-Century Silver Spoon', *Cumberland and Westmorland Arch. Soc. Trans.*, N.S. XIII, 1913, 128-30.

Channel Islands

MAYNE, R. H. *Old Channel Islands Silver*, 1969.

Chester

RIDGWAY, M. H. *Chester Goldsmiths, from early times to 1725*, 1968.
RIDGWAY, M. H. *Some Chester Goldsmiths and their Marks*, Chester, 1973.

Devon and Cornwall

CHANTER, REV. J. F. 'The Barnstaple Goldsmiths' Guild . . .' *Devonshire Assocn. Transactions*, XLIX, 1917, 163-189.
MILLS, Canon H. H. 'West Country Goldsmiths', *Royal Inst. of Cornwall*, XX, 1920, 536-551.
DOUCH, H. L. 'Cornish Goldsmiths', *Royal Inst. of Cornwall*, N.S. 6, ii, 1970, 121.
CHANTER, Rev. J. F. 'The Exeter Goldsmiths' Guild', *Devonshire Assocn. Transactions*, XLIV, 1912, 438-79.
SYMES SAUNDERS, E. G. 'Plymouth Silver', *Devonshire Assocn. Transactions*, LXVIII, 1936, 299-302.
PRATTENT, O. J. 'Marks of the Plymouth Goldsmiths', *Country Life*, October 1960, 901-3.

East Anglia

CASLEY, H. C. 'An Ipswich Worker of Elizabethan Church Plate', *Suffolk Institute of Archaeology Proceedings*, XII, 158-83; XIII, 103.
KING'S LYNN MUSEUM AND ART GALLERY, *Lynn Silver*, Exhibition, 1972.
BARRETT, G. N. 'The Haslewood Family of Norwich Goldsmiths', *Norfolk Archaeology*, 33, 1964, 318-320.
CITY OF NORWICH MUSEUMS, *Norwich Silver, 1565/1706, Loan Exhibition*, 1966.
ELLIS, H. D. 'The Rose and Crown Hall Mark of Norwich Plate', *Burlington Magazine*, XII, March 1908, 363-366.
HOW, G. E. P. 'Norwich Silver. Some constructive criticisms on errors of ascription', *Apollo*, XL, 150-3.
LEVINE, G. 'Norwich Goldsmiths Marks', *Norfolk Archaeology*, 34, 1968, 293-302.

WAKE, T. 'Silver by Norwich craftsmen', *Apollo*, XL, Aug. Sept. 1944, 40-1, 60-2.
R. (J. A.) 'A note on old English provincial silver', *Apollo*, Aug. 1936, 109.

Lewes

HOW, G. E. P. 'The Goldsmiths of Lewes', *Connoisseur*, CLXXIX, Dec. 1972, 246.

The Midlands

JEAVONS, S. A. 'Midland Goldsmiths of the Elizabethan Period', *Lichfield and South Staffs. Archaeological and Historical Soc.*, III, 5, 1962, 5-25.
WESTWOOD, A. 'The Manufacture of Wrought Plate in Birmingham', *Birmingham and Midland Institute Transactions*, XXIX, 1903, 40-62.
BIRMINGHAM CITY MUSEUM AND ART GALLERY. *Birmingham Gold and Silver*, 1773-1973, Exhibition, 1973.

Newcastle

PENZER, N. M. 'The Newcastle Assay Office, its marks and its silver', *The Antique Collector*, XXX, 1959, 104-109, 183-190.

Yorkshire

ALEC-SMITH, R. A. 'Silver Bearing the Hull Assay Mark', *Apollo*, LIV, Sept, 1951, 75-8.
OMAN, C. C. 'Goldsmiths of Kingston-upon-Hull', *Connoisseur*, CXXVIII, 1952, 182-5.
LEE, W. 'Rare Yorkshire Church Plate', 'More light on Yorkshire Church Plate', *The Antique Collector*, XXXVIII, 1967, 88-94, 138-9. On Leeds marks.
SHEFFIELD CITY MUSEUM. *Sheffield Silver* 1773-1973, Exhibition, 1973.
LEE, W. 'York Silver Spoons 1500-1700', *The Antique Collector*, XXXII, 1961, 239-44.
LEE, W. *York silver 1475-1858, a permanent exhibition*, York Minster Undercroft, William Lee, 1972.
BAKER, H. G. 'The York Goldsmiths, an unrecorded maker's mark', *Yorkshire Archaeological Journal*, XXIX, 108.

APPENDIX

The following are among the more notable collections, chiefly of early spoons, to have passed through the saleroom.

Brand; Christie, 13 April 1905.
Breadalbane; Christie, 12 May 1926.
Dawson; Sotheby, 16 Feb. 1961.
Ellis (medieval and London); Sotheby, 30 May 1935.
Ellis (provincial); Sotheby 13, 14 Nov. 1935, and 15, 16 April 1937.
Harris; Christie, 22 April 1953; 19 June 1957.
Hart; Christie, 28 June 1939.
Harvey Clark; Christie, 13 July 1953.
Marsden Smedley; Sotheby, 17 June 1943.
Noble; Christie, 28 March 1962.
Ransford Collett; Christie, 10 March 1937.
Ridpath; Sotheby, 18, 19 Feb. 1924.
Riley Smith; Christie, 22 April 1953.
Walter; Sotheby, 1, 2 July 1954.

The catalogues of Sotheby's Belgravia are useful for Victorian flatware.